Color Correction and Enhancement

with Adobe® Photoshop®

Michelle Perkins

AMHERST MEDIA, INC. ■ BUFFALO, NY

ACKNOWLEDGMENTS

Many people helped in the creation of this book—my great thanks go out to them all. Of special note for their photographic contributions are Jeff Hawkins, Jeff Smith, Deborah Lynn Ferro, Rick Ferro, Jamie Rae Conley, and Paul Grant (most of whom are also the authors of excellent books, as noted on page 127–8). Additional thanks also go out to Barbara Lynch-Johnt for her invaluable editorial assistance on this and many other projects.

Finally, an extra-big thank you to my husband Paul for his limitless patience—and for dragging me away from the computer when it was definitely much too late to write another word.

Photographs by: Jamie Rae Conley (115), Rick Ferro (30, 36, 103), Deborah Lynn Ferro (116), Paul Grant (34), Jeff Hawkins (53, 54, 56, 74, 78, 97, 102), and Jeff Smith (48, 51, 52, 63, 64, 65, 68, 73, 108). All other photographs by the author.

Front cover photograph by: Rick Ferro © 2004.
Back cover photographs by: Jeff Smith © 2004.

Published by:
Amherst Media, Inc.
P.O. Box 586
Buffalo, N.Y. 14226
Fax: 716-874-4508
www.AmherstMedia.com

Publisher: Craig Alesse
Assistant Editor: Barbara A. Lynch-Johnt

ISBN: 1-58428-123-5
Library of Congress Card Catalog Number: 2003103033

Printed in Korea.
10 9 8 7 6 5 4 3 2 1

Introduction

However you create your photos, chances are good that at least *some* of them don't come out looking quite as you imagined. You may have gotten the exposure wrong, you might have had to shoot under fluorescent light, or you may just feel the color in your image doesn't capture the essence of the scene as you saw it. Back when images were mostly made on film (and stayed on film or paper their whole lives), off-color images went back to the photo lab for correction. With adjustments in printing (or duplication, in the case of slides), lab technicians could do a pretty good job of fixing minor problems. Of course, "pretty good" could still be disappointing, and most people just learned to live with that. After all, short of buying your own color lab, what was the alternative?

With digital came the answer: the potential for complete control over your photographs via a "color lab" in your computer. Of course, as with all new freedoms, this one came hand-in-hand with a lot of responsibility and a number of *new* headaches. Even if your film images looked good in the prints, they might not look so great once you scanned them for your web site. Or your images might look great on screen but awful when you made prints of them. You may even have old photos that used to look perfect, but have become discolored over time—and now *you're* in charge of fixing them.

The good news is that there is virtually no photo so hopeless that you can't make it look a lot better in Photoshop, and there is virtually no way of *using* a photo for which you can't help it look its best. If you have a reasonably good image to start with, chances are very good that you can make it look perfect. The bad news? Accomplishing these transformations requires some work—you'll need to master a number of digital tools. You'll also need to learn some basic color theory. Most of all, you'll need to practice. The most challenging aspect of color correction and enhancement is the fact that it is very subjective. It also requires you

THERE IS VIRTUALLY NO PHOTO SO HOPELESS THAT YOU CAN'T MAKE IT LOOK A LOT BETTER.

to be a bit of a strategist, carefully evaluating the changes that need to be made and developing a plan of action. Rarely will the same strategy work equally well on two different photos. Each image will need to be tweaked and fiddled with on its own, taking into account its own unique characteristics.

Once you've done this, you'll never need to settle again. Your images will have more impact—and better yet, they'll have exactly the impact you want. Once you're in control, you'll probably find making new photos a lot more fun as well, since you can rest assured that you'll be able to create end products that look just right.

● WHAT YOU NEED TO KNOW

This book is designed for readers who already have at least a *basic* knowledge of Photoshop. To use the techniques, you should know how to open and save documents, create and use layers, make selections, etc. If you are new to Photoshop, completing the very effective tour and training manual on the CD that is packaged with the software will be immensely helpful. There are also a number of Photoshop manuals on the market—including my own *Beginner's Guide to Adobe® Photoshop®* (Amherst Media, 2003), which provides a quick way to get up to speed.

ONCE YOU'VE DONE THIS, YOU'LL NEVER NEED TO SETTLE AGAIN.

● GETTING STARTED

There are numerous versions of Photoshop in use today. This book is specifically tailored for Photoshop 7, but can be used successfully with other versions of the software—especially if you are already at least reasonably familiar with using Photoshop. If you are using a much earlier version of the program and are serious about making digital imaging a component of your business or art, it's time to consider upgrading. The additions to recent versions make the software well worth the investment. For a detailed description of the full features, visit the Adobe web site at <www.adobe.com> (this is also the place to check for free downloads to make your software run its best).

1. The Digital File

One thing certainly hasn't been changed by the "digital revolution" in photography: starting with a good original always makes things a lot easier. In the days of film, this meant starting (whenever possible) with a well-exposed, unblemished negative or transparency. In digital, it means (again, whenever possible) starting with a scan or digital capture that doesn't exhibit obvious flaws. The better the image you start with, the less work you'll have to do to make it look great.

Obviously, the digital retouching work we are attempting is sometimes undertaken precisely *because* the image is damaged, poorly exposed, or unsatisfactory in some way. Even in these cases, however, there are some things we can do to help ensure that we achieve the maximum results with the minimum of effort.

● SCANNING

Even if you now shoot completely digitally, chances are pretty good that you'll still need to work with traditional media from time to time—after all, there are still decades worth of film-based images out there to contend with. When scanning an image, there are a number of quality issues to keep in mind. All of these can help to reduce the time you'll later need to spend retouching.

Bracketing. If you bracketed the shot (took several frames at different exposures), you can use this to your advantage. When you have the choice between two images to scan, you'll get better results using a frame that is slightly overexposed (light) rather than one that is slightly underexposed (dark). While you can lighten images in Photoshop, the lightened shadow areas tend to have color shifts and an increased appearance of grain. Darkening images results in a more seamless appearance. So, if all other things are equal in two frames, scan the lighter of the two.

QUICK TIPS
While it's generally easier to darken an image than lighten one, this does not mean you can expect good results from a photo with blown-out highlights. For more on this topic, see page 12.

Cleaning. Using a dust-free cloth to remove fingerprints and dust particles from both the image and the scanner bed (with flatbed scanners) is a big time-saver. The few seconds it takes to wipe down both surfaces can literally save you hours of painstaking retouching work with the Stamp tool or Healing Brush.

Resolution. Once you've selected and prepared your image for scanning, you'll need to decide on the final size and resolution needed in the scan. This is not the time to guess—you don't want to waste your time carefully perfecting your image only to find that the resolution is too low.

If you are unsure of the needed resolution for an image you plan to have professionally printed, check with the lab or printer for their requirements. If you plan to print the image yourself, check the manual that came with your printer for its resolution recommendations. Don't forget to take into account any enlargement from the original print or transparency—larger output will also require a larger scan. If you plan to use your image on-screen only (say, on your web site), you can set the resolution to 72dpi.

If your image has multiple destinations (maybe you want to make a few prints and also e-mail a copy to someone), scan for the highest needed resolution and size. You can reduce the size in Photoshop quite effectively to create the smaller image from the final version of the larger file.

Evaluate the Scan. Once you've cleaned the image and scanned it at the desired settings, take a few minutes to look it over and evaluate the results. If you think another cleaning or some adjustment to the scanner software would help create a more accurate result, then take a few moments to scan the image again—it will take less time than struggling with a not-quite-right scan.

Professional Scanning. For really significant enlargements (say, more than 11"x14"), consider having your print or transparency scanned professionally. Digital service providers offer scans created on professional equipment (like drum scanners). These provide sharper and larger digital files than can be created on even higher-end consumer scanners. The prices on these services have dropped considerably over the past few years, so high quality scans of this type are increasingly accessible and affordable.

● DIGITAL CAPTURE

Digital capture, by eliminating the time and effort needed for scanning, has streamlined digital imaging and truly transformed computers into darkrooms. It's also meant that photographers are increasingly responsible for controlling and fine-tuning the color in their images. As with scanning, though, there are some things you can do to make your life easier.

PHOTOGRAPHERS ARE INCREASINGLY RESPONSIBLE FOR CONTROLLING AND FINE-TUNING THE COLOR IN THEIR IMAGES.

White Balance. Many people rely on the auto white balance in their digital cameras to create accurate color rendition—and digital cameras are pretty sophisticated, so often this works just fine. However, scenes or subjects with a preponderance of one color (say, a red apple on a red backdrop) can trick the auto white balance. Use your LCD or monitor to carefully evaluate the color in these cases.

If color is critical, set the white balance manually to match the light source under which you are shooting. Many cameras also allow you to customize the white balance based on a highlight in your scene—if you do this, don't forget to change the custom setting as the lighting conditions change.

If you have the luxury of experimenting (like with a still life subject), try out different white balance settings to see if one provides more accurate color. Keep in mind, the setting that provides the most pleasing color may not be the one that matches the lighting.

Remember, with enough time and skill, you can correct just about any color problem in Photoshop—but you'll save yourself some time if you eliminate obvious color problems *before* you create the image.

The white-balance setting you choose on your digital camera can greatly affect the color of your images. In the photo on the left, the auto setting was used. In the center photo, the daylight setting was used. In the photo on the right, the tungsten setting was employed.

Exposure. When creating exposures with your digital camera, you should work as you would with slide film and expose for the highlights. One of the notorious problems in digital photography is blown-out highlights. These areas of no-detail white just look bad and rob your image of the texture it should have. Also, once detail is lost in the highlights, it's a daunting and time-consuming task to try to re-create it in Photoshop—and the results may never look quite as good as the real thing.

Blown-out highlights can be tricky to avoid entirely, but you can up your odds by asking subjects (if possible) not to wear white and by exposing for the highlights. In the image review mode, many cameras also allow you to display an image histogram that is very helpful in determining the overall tonal range of the image. (To learn how to evaluate histograms, see chapter 8.) Some cameras also offer a display in this mode that indicates areas of pure white with no detail (either by outlining the areas or making them blink in the display). By taking advantage of these tools, you can often identify and correct problems with the highlights before you even get the image to your computer.

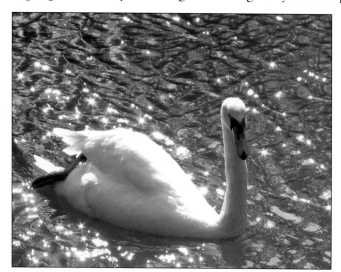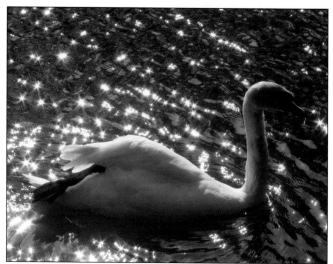

Blown-out highlights, such as on the swan's back in the photo on the left, result in ugly white areas with no detail. Compare this with the photo on the right, which was exposed for the shadows and retains the delicate feather detail across the swan's entire body. In high-contrast lighting situations, metering for the shadows has trade-offs, however. As you can see here, the shadows and the bird's head are somewhat darker than would probably be desired in the final image—but since all the areas contain detail, the exposure can easily be balanced in Photoshop. This will be much easier than trying to restore the lost detail to the feathers in the image on the left.

● LOST CAUSES

Is any image ever really a lost cause? The answer to that depends less on what Photoshop can do than on how much patience you have. If your image is reasonably well exposed, chances are you can make it look perfect. If it is seriously over- or underexposed, you can probably make it look a lot better—but it will take a bit more time. Images with overall color problems due to processing errors can often be fixed up quite easily; ones with blotchy drips from spilled chemicals can almost always be helped—but serious patience may be required. Even if an image is in really sad shape, it's almost always worth a try—particularly in cases where it's not possible to reshoot, as with old family photos.

Whether or not you can "successfully" correct the color in a particular image also depends on your definition of "success" for that image. In some cases, really tricky images can inspire unique color solutions that take the image in a totally different direction than you planned.

Even photos that have serious problems can almost always be reborn as stylized, abstract, or artistic images. Often, a maddening color problem virtually disappears when you present the image as a sepia-toned photograph. Applying a filter or using an extreme contrast setting may also transform a frustrating image into an appealing one.

Ultimately, your options are only as limited as your creativity and your patience—so don't count any image a lost cause before you've fully explored all of the possibilities.

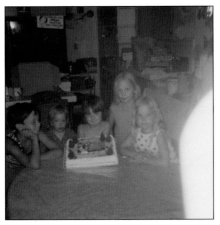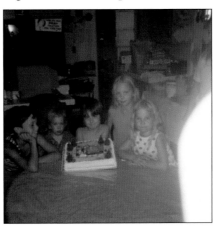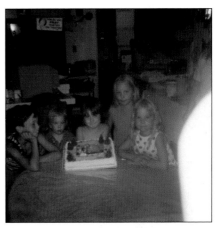

The birthday boy in the photo is now in his thirties and the 110 negative is long lost. The print (top left) had exposure problems to begin with (the image is very overexposed on the right) and is now getting pretty faded. By making some basic color adjustments (middle and right), the photo was improved a lot in just a few minutes.

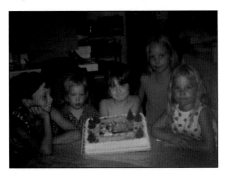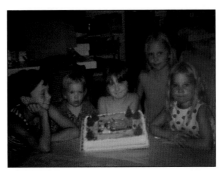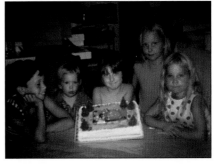

Cropping the image helped, but more work was needed to bring the girl on the right into balance with the exposure on the other subjects. A vignette was also added to disguise some of the background and to eliminate the need to spend any time on its color. As you look through the images from left to right, you can see how the color improves.

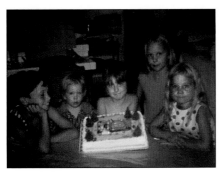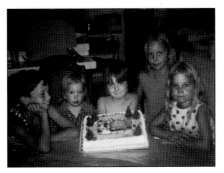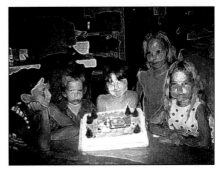

There is no reason you can't present a color image as a black & white or sepia one (left and center); this often even helps to reduce visual clutter and keep the focus on the people. Conversely, you can use over-the-top color (right) and/or apply filters to create a pop-art, watercolor, or other style of image—the choice is entirely yours.

2. Color Perception

The good news is: millions of years of visual adaptation have made humans excellent interpreters of color. The bad news is: millions of years of visual adaptation have made humans excellent interpreters of color.

● FAMILIARITY

As people who see color all around us every day, colors are something that appeal and communicate to us. We are also very demanding about color for the same reason—we know how things are *supposed* to look, and when they don't look that way we notice it immediately. Even if we don't know what the problem is or how to fix it, we still see it.

Unfamiliar colors or ones that we know are variable (foliage can range from a yellow-green to a blue-green and look acceptable to most

FACING PAGE: *Which of these photos shows the "correct" color of the tulips? Does any of them? When presented with three choices like this, most people pick the middle one. Here, the top photo happens to be the original—but does it even matter? For a botany textbook, it probably does. For a greeting card, probably not.*

 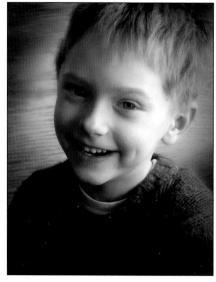 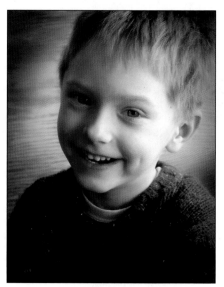

When skin tones are off, we usually notice them right away. Here, the original image is in the center. Adding (left) or decreasing (right) the cyan in the image by a very tiny amount really changes our perception of the skins tones dramatically.

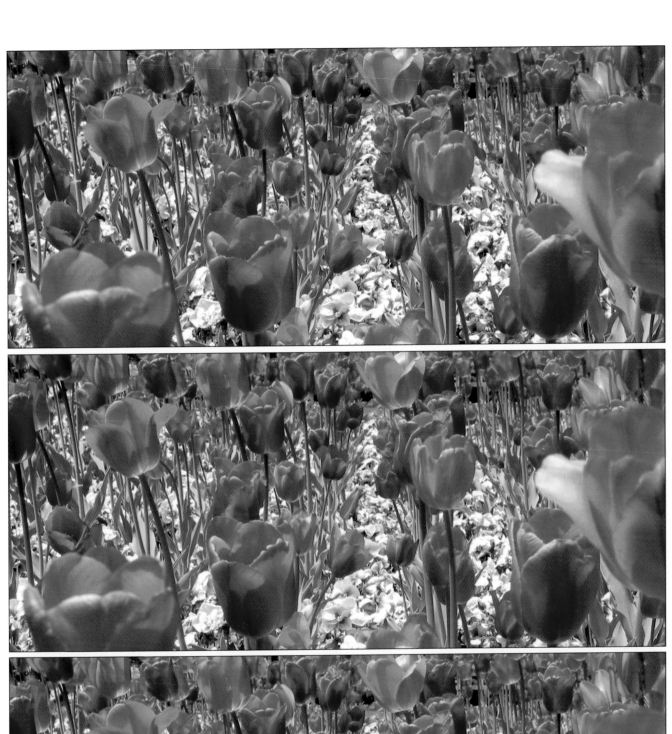

people) sometimes cut us some slack. This isn't always the case, though. Imagine you were making a foliage photo of a plant for a botany textbook—then accurate color would be very important.

Familiar colors, however—like the yellow of a banana, the red of a fire truck, the color of a favorite sweater—are especially jarring when they just aren't right. What's more, the most familiar colors of all also happen to be the most varied and subtle ones—human skin tones.

● SUBJECTIVITY

Want more good news? Color is extremely subjective. As it happens, this is not just a matter of whether you like blue better than purple—it's a fact of biology. Our eyes actively work to preserve the appearance of object colors in changing light, to enhance color differences between objects and their surroundings, and to inform our perception of color using our memories of what objects look like.

While this is a marvelous thing in terms of survival (differentiating poisonous berries from those that are safe to eat, seeing the green snake hiding in the foliage up ahead, etc.), it has an obvious drawback for people concerned with reproducing colors accurately.

Before we get too far into our look at how these phenomena manifest themselves, however, let's take a minute to review some basic biology and get to the root of things.

● COLOR VISION

Did you know that it's not really our eyes that see? Sure, our eyes detect light—which is very nifty—but until they send the information about what they've received to our brains, we don't actually know whether that thing blocking our path is a car, a cat, or a canoe.

The retina contains two kinds of light receptors: rods and cones. Rods are activated in low-light situations and have no color sensitivity. Cones are stimulated by large amounts of light and are sensitive to color.

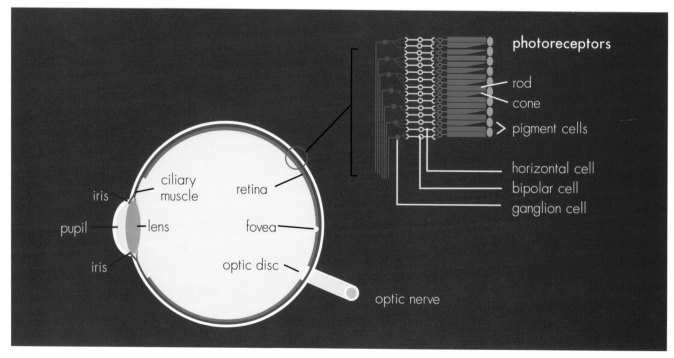

photoreceptors

rod

cone

pigment cells

horizontal cell
bipolar cell
ganglion cell

iris

ciliary muscle

retina

pupil — lens

fovea

iris

optic disc

optic nerve

The retina, located in the back of the eyeball, contains two types of light-sensitive devices: the rods and the cones. The rods work only in low-light situations and are not sensitive to color. The cones work in situations with more light and are sensitive to color. These color-sensing cells in our eyes see all wavelengths of light at once (they can't see just red wavelengths, for instance) and send the data out to the brain. The brain then has the task of sorting out all the data into a meaningful, usable form.

The figure to the right is called a scintillation grid. Look at it straight on (not from an angle) and let your eyes drift over it slowly. While this is obviously a static image, you should notice that the white dots seem to "scintillate," blinking between white and black, especially at the periphery of your gaze. While there is controversy over exactly what causes this effect (a phenomenon called lateral inhibition seems to be involved), it's a good example of how your brain sometimes interprets the data in ways that don't mesh strictly with reality.

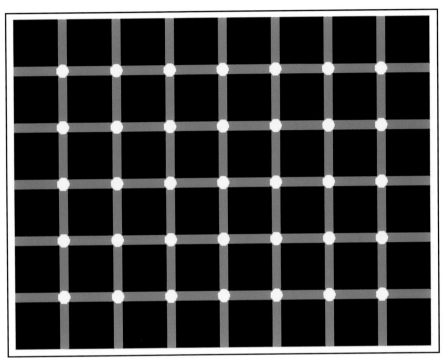

● VISUAL PHENOMENA

Chromatic Adaptation. Evolution has decided for us that as the brain sorts through the data it receives from the eyes, it should try to standardize it in order to give us the best possible information by which to survive. As neurobiologist Semir Zecki of University College, London, noted in a recent study on color perception, "Color constancy is the most important property of the color system." If you think about it, color would certainly be a poor way of categorizing and labeling objects if the perceived colors kept shifting under different conditions.

The phenomenon by which the consistency is created is called chromatic adaptation. As a result of it, blue objects always look blue—whether we see them under fluorescent, natural, or incandescent light. Chromatic adaptation occurs because we do not determine the color of an object in isolation—our perception of one color is intrinsically linked to our perception of the colors that surround it. In the warm light of sunset, a yellow lemon may reflect more red wavelengths of light and appear orange, but the surrounding leaves will also reflect more red light. As a result, the brain compares the two and cancels out the increased levels of red.

You can experiment with this by turning on a household incandescent light in a room that has previously been lit only by the sun. At first, the light from the bulb will look pretty orange. But gradually, your eyes will compensate for this and it will begin to look white.

Chromatic Induction. As noted above, we do not consider colors in isolation. While this is usually helpful to us, it can sometimes cause confusion. As our brains work to help us differentiate colors, identical colors sometimes look different when viewed in contrast with different surrounding colors. This can make colors seem brighter or darker than they actually are, causing them appear to be tinged with the comple-

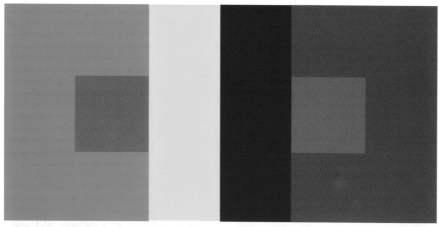

Believe it or not, the small green squares in the center of the diagram are the identical color and shade. You can prove it to yourself by covering up the colors that surround them. This effect is a result of chromatic induction.

Here's another example of the way that colors affect each other. The colors in the diagram on the right look a bit pale when compared to the colors in the diagram on the left. The only difference between them, however, is that the colors on the left are surrounded by black.

Looking at the inset boxes in the top part of each half of this diagram, the colors look pretty much the same. It's not until you follow the lines down to the bottom of the diagram to the stacked rectangles that you realize how different they are. This is another example of chromatic induction.

mentary hue of the surrounding area (see page 21 for more on complementary colors).

● REFLECTED VS. LUMINOUS SOURCES

When you are looking at a print, chromatic adaptation presents no problem. Since your eyes are already balanced to the ambient light, color shifts in the print (which just reflects this light) will be perfectly obvious. Unfortunately, the same is not true with luminous sources, such as your computer monitor.

When we look at a source of light, our eyes are constantly calibrating to it. That means that the longer you stare at your image on the monitor, the more neutralized the image becomes. This can make you think it's okay when it's not. When it comes to judging exposure (particularly highlights), you also need to be aware that the luminous monitor makes our pupils close down. This can lead us to think that there is more highlight detail than there actually is.

Because what we see with our eyes is so subjective, it will be important for you to learn to use and rely on the objectivity of the Eyedropper tool. The use of this tool is presented on pages 31–34.

● COLOR VIEWING AREA

Your eyes will adapt to your monitor no matter what you do, but taking control of your viewing environment can help to manage the situation. First, you can accurately color balance your monitor using any of the multitude of hardware and software devices designed for this task (see pages 121–22 for more on this topic). Once this is done, select a neutral gray for your computer's desktop pattern. Because the color of the environment around the monitor can cast color reflections onto it, create a viewing environment that is as neutral and constant as possible. Place your computer in a room with white or gray walls and position it so that there is no glare on the screen. Wear dark, neutral-colored clothing when working on color-sensitive projects. Additionally, you'll need to keep the light levels (and types) in the room constant throughout the day, and from day to day.

THIS CAN LEAD US TO THINK THAT THERE IS MORE HIGHLIGHT DETAIL THAN THERE ACTUALLY IS.

3. The Basics of Color

● PRIMARY COLORS

If you ever took an art class (or even played around with watercolors as a kid), you probably know that combining two or more colors creates new colors. For example, combining blue paint and yellow paint makes green paint. In fact, almost all colors are actually combinations of some other colors. The exceptions (the very few colors you can't create by combining others) are called the primary colors. The primary colors are divided into two sets: additive and subtractive.

Subtractive Primaries. The subtractive primary colors are red, green, and blue (RGB). When combined at full strength, the subtractive primary colors yield white. When the colors are all absent ("subtracted"), the result is black. This set of colors, the one we will be using most often in this book, is the set used to create color on your monitor, digital camera, television, etc.

Additive Primaries. The additive primary colors are cyan, magenta, and yellow. This set of primary colors is used in printing, where inks reflect back light that hits the paper on which a color image or color text appears. When combined at full strength ("added"), the additive primary colors yield black (at least theoretically—see pages 25 and 27 for

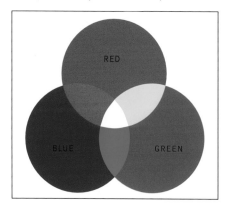 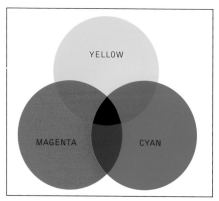

The RGB and CMY color models. As you can see by looking at the center of each grouping, the presence of all colors yields white when using the RGB set of primary colors, and black when using the CMY primary colors.

more information on this topic). When the colors are all absent ("sub-tracted"), the result is white.

● COMPLEMENTARY COLORS

As shown below, the primary colors are often represented on a color wheel. The colors that are directly across the wheel from each other are considered complementary. This means that when they are combined in equal amounts, the result is neutral gray. This neutralizing effect of complementary colors is used to great advantage in photography—think of light-balancing filters, for example. What color filter neutralizes the yellow cast of incandescent lighting? It's blue, the complement of yellow.

Things work just the same way in color correction with Photoshop. Let's consider an example. Imagine, again, you have an image that was taken under incandescent light and seems too yellow. How will you fix that? Well, you could try removing yellow—and it might work. But if you think of the color wheel and complementary colors, you'll know that you can also try adding blue. In many cases, this will yield much better results.

If you make a mental note of this chart (or have it on hand for reference), you'll have at your fingertips one of the most important resources for color correction.

The color wheel shows both RGB and CMY colors. Colors directly across the wheel from each other are considered complementary.

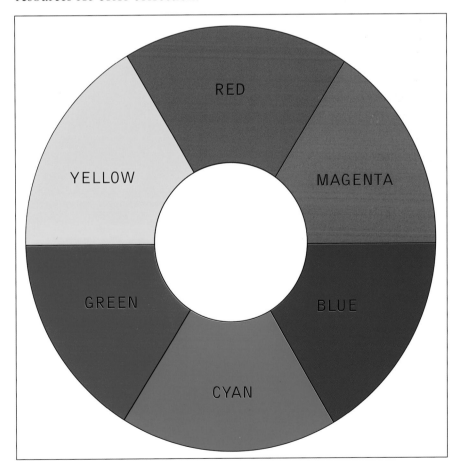

4. Digital Color

● COLOR MODES AND CHANNELS

In digital imaging, the set of primary colors that are used to create all the other colors in your image is collectively referred to as the color model (or in Photoshop as the color mode). You can set the color mode of your image by going to Image>Mode and picking from the list.

The individual colors within the set are called channels. For example, if your image is in the RGB mode (the most commonly used mode in Photoshop), then all of the colors in that image are made up of some combination of red (R), green (G), and blue (B). If your image is in the CMYK mode, then all of the colors in that image are made up of some combination of cyan (C), magenta (M), yellow (Y), and black (represented by the letter K). Thus an RGB image has three channels, while a CMYK image has four channels. Other color modes have other numbers of channels, too.

THE INDIVIDUAL COLORS
WITHIN THE SET
ARE CALLED CHANNELS.

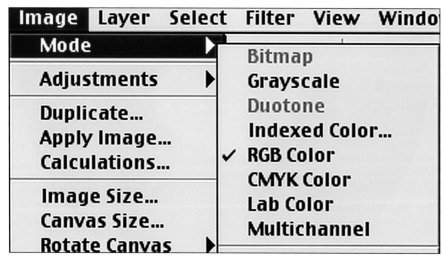

The color mode of an image determines the set of colors that will be used in creating the colors within it.

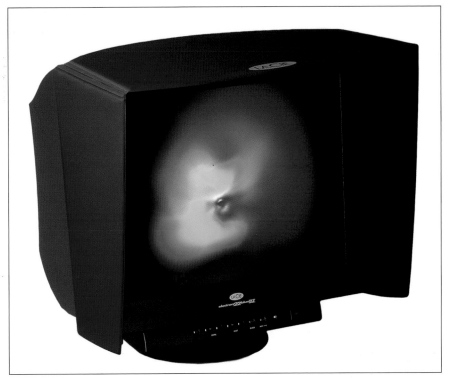

Monitors, scanners, and digital cameras are all RGB devices. This is because they create or display images either by receiving or transmitting light.

Each color mode has its own specific assets and applications. Let's look at the most commonly used color modes and their uses.

RGB. Human eyes, scanners, digital cameras, and monitors—devices that receive or transmit light—all capture or display color using this model. RGB is also the default mode in Photoshop, and the mode in which digital images (whether scanned or captured on a digital camera) normally begin their life.

In the RGB mode, an intensity value ranging from 0 to 255 for each color (R, G, and B) is assigned to each pixel in the image. When all three values are set to 0, the resulting color in the image will be black. When all three values are set to 255, the resulting color in the image will be pure white—the reason that this set of primary colors is called additive (see page 25 to contrast with the subtractive CMYK set). When all three colors are set identically to an intermediate value (for example R=100/G=100/B=100), the resulting color in the image will be a shade of neutral gray.

By combining unequal values of R, G, and B, you can create about 16.7 million other colors. Because of this, RGB is described as having a wide gamut, a term used to describe the total range of colors (or the tonal range) that can be produced. As you'll quickly learn when you begin working with digital images, however, the RGB gamut, wide as it may be, is still not as wide as the gamut of the human eye. As a result, subtle colors that your eyes can distinguish in a scene may render as a single tone in RGB. While this doesn't normally present a tremendous problem, it's a deficiency in color range that we pretty much just have to learn to make the most of.

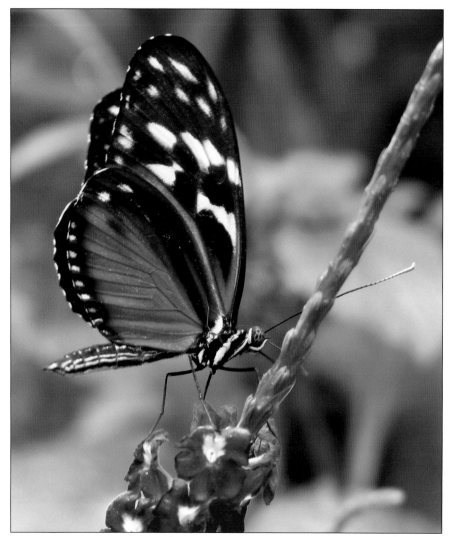

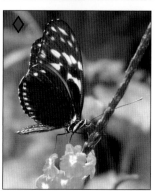

A full-color image (above) contains three grayscale channels in the RGB mode—one for each color. The amount of an individual color is reflected by the tonal variation (from light to dark) in the grayscale. As noted on page 20, RGB is a subtractive model, meaning that when all colors are at their maximum intensity of 255, the result is white. Therefore, in each channel, the lighter the area in the channel, the more of that color there is in the area. For an example of this, look at the orange area of the butterfly's wing. In this area, the red channel is very light, meaning there is a lot of red there. The green channel is also somewhat light, meaning there is also some green. The blue channel, however, is nearly black, revealing that there is very little blue in this area. To compare this with the CMYK color model, see page 25.

For this book, we will be working almost exclusively in the RGB mode. This is because it is the easiest to learn and offers the most options (most Photoshop features work in other color modes, but *all* work in RGB).

Depending on how you want to use your images later, you can convert to the desired mode. To change the color mode of an image, go to

Image>Mode and select the desired color mode from the list. For the Internet (e-mailing images or using them on a web site) and home or lab printing of photographs, however, RGB is usually the mode that will be required for the final output of the images.

CMYK. The subtractive color mode (so named because the total absence of all colors produces white) is used for process-color printing—the type of printing that is used to create magazines, books, posters, packing labels, and other items. CMYK is the color space used when the color in the final image is to be created by reflecting light off the image, as in printed matter.

In the CMYK mode, a value ranging from 0% to 100% for each color (C, M, Y, and K) is assigned to each pixel in the image. When all the values are set to 0%, the resulting color in the image will be white. For information on creating pure black in the CMYK mode, read on—the story gets a little more tricky.

If you own a color inkjet printer, you'll notice that the colors of ink it uses to print are cyan (C), magenta (M), yellow (Y), and black (K). If you own a more sophisticated inkjet printer, it may have additional red and blue inks as well. Why is this?

Well, the answer is that the CMYK color gamut is smaller than the RGB gamut—meaning fewer colors can be produced. In fact, you'll notice in the right-hand illustration at the bottom of page 20 that the actual set of subtractive colors are just C, M, and Y. This is because inks just aren't as spectrally pure as light waves. While, theoretically, a color of C=100%/M=100%/Y=100% *should* produce pure black, in the real world it tends to produce a murky off-black. To solve the problem, black ink (referred to by its last letter, since "B" could be mistaken for indicating blue) was added to the equation—increasing the gamut and yielding the CMYK color mode.

For the same reason, additional inks are often added to inkjet printers to help enhance the color rendition. Red and blue are common additions since intense shades of these colors are notoriously difficult to ren-

ADDITIONAL INKS ARE OFTEN ADDED TO INKJET PRINTERS TO HELP ENHANCE THE COLOR RENDITION.

On the left, a "black" created using only cyan, magenta, and yellow (C=100%/M=100%/Y=100%). On the right, a much better black is created with the addition of a black ink (C=70%/M=60%/Y=20%/K=100%).

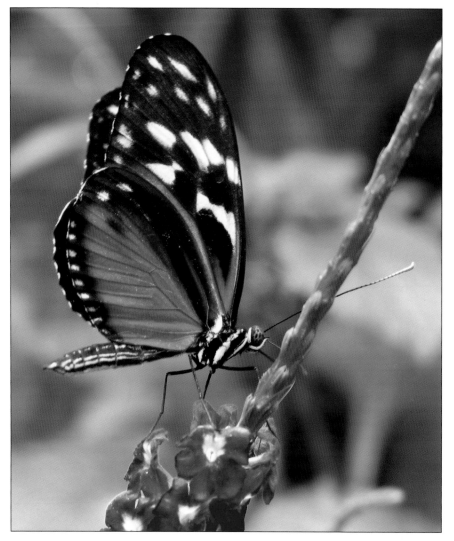

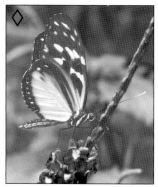

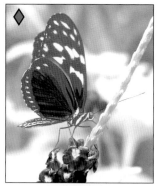

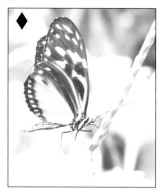

A full-color image (above) contains four grayscale channels in the CMYK mode—one for each color. The amount of an individual color is reflected by the tonal variation (from light to dark) in the grayscale. As noted on page 20, CMYK is an additive model, meaning that when all colors are at their maximum intensity of 100%, the result is black. Therefore, in each channel, the darker *the area in the channel, the* more *of that color there is in the area. For an example of this, look at the orange area of the butterfly's wing. In this area, the magenta and yellow channels are very dark, meaning there is a lot of magenta and yellow there. The cyan and black channels , however, are quite light, meaning there is little of those colors in this area.*

der with the basic four inks. Many high-end art books, advertisements, and packagings, where color is absolutely critical or signature colors must be matched perfectly (think of Coca-Cola's trademark red), also employ six-ink printing.

As noted previously, the RGB gamut is narrower than the gamut of the human eye—but the CMYK gamut is even narrower than that. As a result, subtle colors that you see in your on-screen image in the RGB

mode may suddenly disappear when you convert the image to CMYK. This is an especially notorious problem with bright reds and blues, which are difficult to render in CMYK.

Grayscale. The Grayscale color mode consists of only one channel—black. Like the channels in CMYK, the tonal variations of this channel are measured in terms of percentages from 0% to 100%, with 0% being white and 100% being black. Generally, the only reason to convert an image to the Grayscale mode is in order to print it using only black ink. This is common in newspaper printing, for example, and in some books, magazines, and newsletters where the budget does not allow for process-color printing.

It may seem logical, whatever the intended output, to use the Grayscale mode to print or display *all* black & white photos—but this is definitely not the case. The reason comes back to gamuts.

If you think about it, with a single ink varying from 0% to 100%, you can create a whopping 100 tones—a far cry from the 16.7 million in the RGB mode. And, in practice, the news is usually worse than that, since creating a continuous tone on a printing press (without ugly areas of bare paper or pure black ink) usually requires you to set the maximum highlight brightness in the 2–5% range, and the maximum shadow darkness in the 95–98% range. Therefore, you may only have 90 tones with which to render your image.

When you have the option to present your image with multiple channels (be it on-screen in RGB, or in print with CMYK or duotone printing [see below]), you'll get better results. To stay in a multi-channel mode and create a black & white image from a color one, see chapter 12, which provides step-by-step instructions.

QUICK TIPS
When you work in a color mode other than RGB—whether it's Grayscale or CMYK—the image you are seeing on screen is still RGB. Why? Because your monitor is an RGB device—it emits red, green, and blue light waves in different combinations to create the colors you see. When you are working on a non-RGB image on screen, what you are seeing is an estimated preview. Therefore, expect to do some experimenting when outputting in these color modes. See chapter 13 for more on this topic.

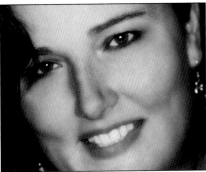 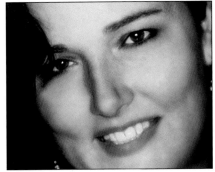

Although sometimes a necessity, black & white images printed with a single ink (left) lack the depth of tone that can be achieved by printing them with four inks (right).

Duotone. The Duotone color mode, as the name implies, is normally used to create an image that will be printed with two inks—usually black plus another non-CMYK color (see page 97). This can be done in order to add the visual appeal of color without the cost of four-color printing. It is also used in some art photography books to create high quality, neutral-toned renditions of black & white photographs.

As you would guess, adding a second channel to the image means that the Duotone mode offers a wider gamut than the Grayscale mode. From the Duotone mode, you can also select to make Tri-Tone (three-ink) and Quad-Tone (four-ink) images that employ non-CMYK inks and further expand the color/tonal gamut.

In order to convert to the Duotone mode, your image must first be converted to the Grayscale mode.

Indexed Color. The Indexed Color mode allows you to limit the total palette of colors used in your image, reducing the file size while retaining visual quality. On web pages, where quick upload times for images is often much more important than color fidelity, this is a very useful format. It is also commonly used when preparing images for other on-screen uses, like multimedia presentations.

THE INDEXED COLOR MODE
ALLOWS YOU TO LIMIT
THE TOTAL PALETTE OF COLORS USED.

At most, the Indexed Color mode allows you to use 256 colors. If a color in the original image does not appear in this range of colors, the program chooses the closest one or simulates the missing color using the available ones.

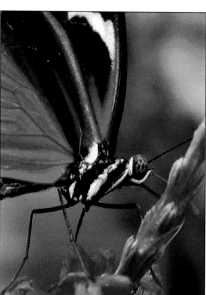

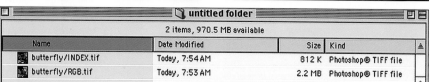

A color image in either the RGB or CMYK mode (left) offers a relatively wide gamut that permits the subtle rendition of colors. The image on the right was switched to the Indexed Color mode and set to 100 colors. As you can see in the screen shot above, this reduced the file size from 2.2MB to 812K—which would make it significantly quicker to download or view on-line. There is definitely a reduction in visible quality, but depending on the use of the image, it might not be objectionable. If 256 colors had been used, the quality reduction would have been almost unnoticeable, but the file would have been slightly larger.

You can also use fewer than 256 colors, reducing the file size and image quality in the process. The trade-off between load time and image rendition is a subjective one. After all, you don't want people to leave your web site because they are tired of waiting for images to load, but you also don't want them to think your images (or products, or family photos) look terrible when they do appear.

To convert to the Indexed Color mode, your image must be in either the RGB or Grayscale mode. Only limited image editing is available in this mode, so it's best to complete any needed image adjustments or enhancements in RGB, then convert to Indexed Color.

Lab Color. Although written as "Lab," this color mode has nothing to do with laboratories and is properly pronounced "L–A–B." Outside of Photoshop, it is more often noted as "l*a*b" or CIELAB (for the Comission International de l'Eclairage, an international color standards organization). The name of the color space is actually sort of an acronym for the components used to make up colors in this mode: L (lightness), A (the arbitrary notation for the red–green opposition channel), and B (another arbitrary notation—this time for the blue–yellow opposition channel).

As you may already have guessed, this mode is a little less intuitive than the ones discussed so far—but keep in mind two facts. First, Lab Color lets you keep color and contrast separate. In CMYK or RGB, every color channel affects both (color and contrast); in Lab, the L channel affects lightness (and thus contrast), while the A and B channels affect only color. Second, the Lab Color mode has the largest gamut in Photoshop—containing all the colors in both CMYK and RGB.

A diagram of the Lab Color model. The black-to-white gradient rod that runs through the center represents the lightness (or "L") channel. The A channel (red–green opposition) and B channel (blue–yellow opposition) intersect the lightness channel and constitute the largest color gamut in Photoshop.

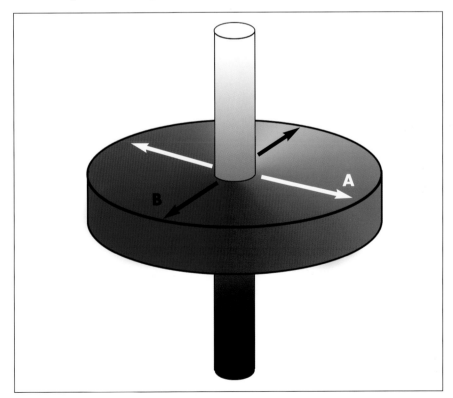

5. Image Preflight

The natural tendency when beginning to color correct an image is to open it and start pressing buttons, clicking and dragging, etc. Doing this, however, is sort of like taking a picture without bothering to compose it—only once in a blue moon will you happen to achieve the best results. (But playing with Photoshop *is* fun, so go ahead and hit buttons for a few minutes if you need to—just be prepared to revert to the original image when you're ready to get serious.)

As with most things, developing a good plan of action before diving into an activity will minimize frustration and enhance success. Therefore, when you scan or open an image and notice that it needs to be color corrected (or if you open it *because* it needs color help), you'll need to figure out exactly what the problem is.

At first, it will probably seem like this process, which we'll call preflight, takes a long time. As you do it more and more, though, you'll find that it actually becomes second nature. With a bit of experience, you'll be able to run

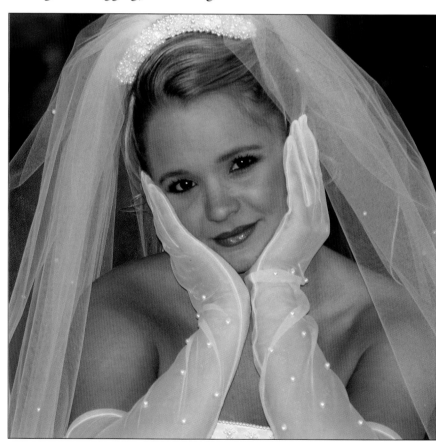

Begin by analyzing your photo. Are the darkest areas dark enough? Are the lightest area light enough? Here, they seem to be fine—the darkest area (the shadow near the bride's shoulder at the right edge of the frame) is dark and rich, while the highlights (the white accents on her gloves, gown and veil) are clean and white. Photo by Rick Ferro.

through the preflight process for most images (at least ones without serious color or exposure problems) in a matter of seconds.

With images that require intensive color help, you may also want to return to this preflighting concept periodically throughout the color correction process. This will help you ensure that your improvements are taking the image in the right direction, aid in identifying what work still needs to be done to achieve your goals, and sometimes reveal secondary problems that went unnoticed in the first preflight.

YOU MAY WANT TO RETURN TO THIS PREFLIGHTING CONCEPT THROUGHOUT THE COLOR CORRECTION PROCESS.

● EYEDROPPER TOOL

Once you've opened your image in Photoshop, you have two valuable tools at your disposal for evaluating it: your eyes and the Eyedropper tool. Your eyes provide more subjective results, while the Eyedropper tool provides results that are totally objective.

In chapter 2, we examined how the eye—or actually, the *brain*—treats color subjectively and can sometimes fool us into thinking things look different than they actually do. This makes the objectivity of the Eyedropper tool especially valuable when you are trying to closely analyze colors.

The Eyedropper tool samples colors, allowing you to see the color value of pixels (displayed in the Info palette) as you evaluate an image. Let's look at an example.

1. Open an RGB image in Photoshop and select the Eyedropper tool from the toolbar.

2. In the Options bar at the top of the screen, set the sample size to "3 by 3 Average." This allows you to read the average value of three pixels within the area you click on in the next step. This averaged reading provides a better sense of the tone and color of the area than reading a single pixel.

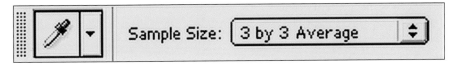

3. Next, verify that the Info palette is visible on your screen. If it's not, go to Window>Info.

4. With the Eyedropper tool still active, move your cursor over your image and watch the Info palette. You'll notice that the RGB and CMYK values change as you move the cursor over different areas of the frame.

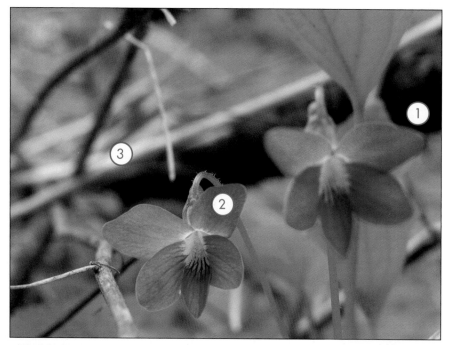

Original image with sample areas highlighted.

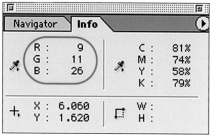

Info palette reading for sample 1

Info palette reading for sample 2

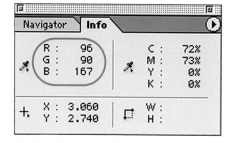

Info palette reading for sample 3

When you move the Eyedropper over a very dark area of your image (see sample area 1, above), you'll see that Info palette shows low RGB values. As you'll recall from chapter 4, this is because RGB is a subtractive color model, meaning that the absence of all colors yields black—so the lower the RGB values, the darker the color.

Under CMYK in the Info palette, the numbers are quite high. This is because CMYK is an additive color model, meaning that the presence of all colors yields black (refer to page 20 for more on this). So, the higher the CMYK values, the darker the color.

Continuing to look at the Info palette reading for sample 1, notice that the blue value (under RGB) and the cyan values (under CMYK) both have slightly higher values than the other channels. This tells you that there is a bit of a bluish cast in this shadow area—very typical of shadows created in natural light under a blue sky. It's not a problem in this case, but if this were a portrait where you wanted a very warm look,

it might be an issue you'd choose to address. We'll cover techniques you could use to do this in later chapters.

Speaking of blue, take a look at the Info palette readings for sample area 2. Here, the red and blue (or cyan and magenta) readings are both high, yielding a purply-blue color on the petals of the violet.

Finally, in the Info palette for sample area 3, you can see that the RGB readings are very high and the CMYK readings are very low. Even if you didn't have a photo to show you what this was a reading of, the values alone would tell you that this is a very light area. Looking at the yellow channel in the CMYK reading, you could also tell that it has a slight yellow cast (the yellow reading is significantly higher than the cyan and magenta readings).

Color Sampler Tool. In the toolbar, if you click and hold on the Eyedropper tool icon, you'll be able to select the Color Sampler tool. This tool allows you to place color-sample reference points on your image and refer to them as you work—even if you close and reopen the image (but don't worry, they don't print).

Once the tool is selected, simply set the sample size to "3 by 3 Average" in the Options bar (see page 31). Then, move your cursor over the image and click to create sample points. You can have up to four sample points per image.

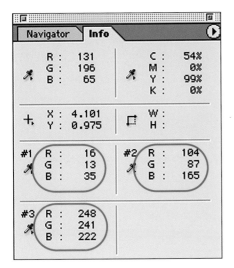

Info palette showing color information for the current sample area (cursor position) at the top of the palette, and information for three markers (numbered 1–3) at the bottom of the palette.

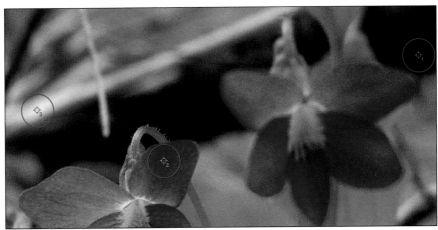

Color Sampler markers in place on the image.

Adding Color Sampler markers will expand your Info palette, as seen to the left. For each marker you add, a corresponding numbered color reading will appear. As you work, you can refer to these to ensure that you are creating just the tones you want, or that changes you make to improve the color in one area don't have a negative effect on the color in another area.

If you'd like to move a sample point, just choose the Color Sampler tool again, and click and drag the marker to a new area of the image. To delete a marker, use the Color Sampler tool to drag the marker out of the window, or press Opt/Alt and click on the marker. To remove all

the markers, click on Clear in the Color Sampler tool Options bar at the top of the screen. You can also hide the markers by going to View> Extras (repeat the process to make the markers visible again).

● SHADOWS AND HIGHLIGHTS

One common problem that can make both black & white and color photos look less than perfect is the absence of a deep rich, black and a bright, sparkling white. For most images (see the exceptions noted on page 35), achieving a pleasing sense of the overall color requires the use of the full range of possible tones from black (or very near black) to white (or very near white). Our eyes adjust to see this full range of colors in almost every scene we view around us, so if a photo lacks it we immediately feel that the image looks flat or dull.

So, ask yourself: Are the darkest areas in this photo dark enough? Are the lightest areas in this photo light enough? Keep in mind, some images may have one problem or the other, some may have both and some may have no problem at all in this area. If you are looking at an image that was scanned from a print, slide, or negative, keep in mind that the scanning process can sometimes negatively affect the tonal range of the image, so even if your original was good, you should still evaluate the black point and white point of your scan.

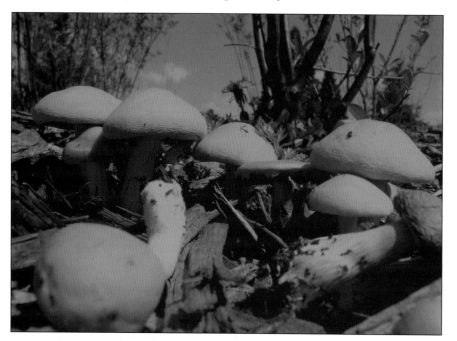

In this image, the contrast is pretty bad—the photograph looks flat and muddy. Looking at the bottom left Info palette, you can see that the RGB values of a sample taken on the highlight area (the bright mushroom stem) are not quite high enough. While getting a pure white reading of R=255/G=255/B=255 might not be desirable (we'd like some detail), values around 250 across the board would create a more brilliant highlight. Looking at the bottom right Info palette, you can see that the RGB values of a sample taken on an area of deep shadow are not quite low enough. Readings well under 10 across the board would create a nice deep shadow. Photo by Paul Grant.

In this image, the contrast is much better. Looking at the bottom left Info palette, you can see that the RGB values of a sample taken on the same highlight area are now all over 250—creating a bright highlight that still has some detail. Looking at the bottom right Info palette, you can see that the RGB values for the sample area of deep shadow are now at 5 for a deep, rich shadow.

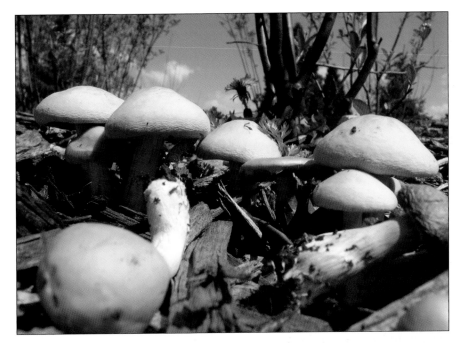

Keep in mind we are only analyzing the image at this point, not adjusting it. So make notes (mental or otherwise) on your findings, but don't worry about correcting any possible problems just yet—there are still other variables to consider, and your future findings may impact how you decide to deal with any possible problems you've identified at this point.

Exceptions. There are, or course, some exceptions. If you've taken a very high key photograph (a marshmallow in a snowbank), there may well not be any deep, dark tones. In very low key images (a black cat in a coal bin), there may not be any areas of pure white. Keep in mind however, that such instance are very rare. For even most high-key images, there are some areas that are naturally dark—even if it's just the color of the subject's eyes. In most low key photos, it is desirable to have some very light highlights to show the shape and texture of the subject. Again, ask yourself: Are the darkest areas in this photo dark enough? Are the lightest areas in this photo light enough?

There may also be instances where, for creative reasons, you choose not to use the full range of tones in your image—in that case, you can move on to the next category of analysis.

● NEUTRALS

If windows are the eyes to the soul of a person, neutral tones are often the key to learning what's going on under the skin of a digital image. If the neutral tones have a color cast, chances are that the rest of the image does too.

Whites. A good place to start is with the whites. Keep in mind, the whites you evaluate should be areas of pure (or very close to pure) white—like a catchlight, a cloud, a white bridal gown, etc. Although we often refer to the "whites" of the eyes or to people's teeth being white, they rarely are.

Once you've identified an area to evaluate, examine it closely for any slight shifts in color—what looks at first glance to be white often turns out on closer inspection to be faintly yellow, or blue, or pink.

HUMAN EYES ADJUST QUICKLY TO NEUTRALIZE OVERALL COLOR CASTS.

Your eyes can deceive you, though. As was discussed in chapter 2, human eyes adjust quickly to neutralize overall color casts (a great adaptation for survival, but a frustrating one for color correction). Even if you're pretty sure there's no color cast in your white area, it won't hurt to evaluate it more carefully.

Select the Eyedropper tool and move it around in that area, looking at the readings in the Info palette. The closer the R, G, and B readings each are to 255, the closer the color in the area is to pure white. If one or more of the readings seems to consistently fall more than a few points below 255, the white area probably has at least a small color cast.

Bear in mind that a small color cast may be fine—this is a subjective decision that is yours to make. For example, if white clouds on a blue

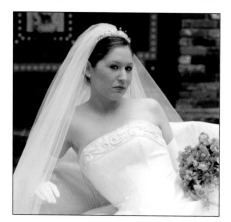

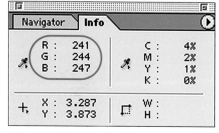
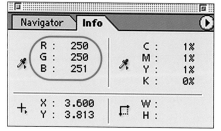

On the left, the Eyedropper readings on the white gown showed blues that were consistently high. By reducing the blue in relation to the other colors, the image became better color balanced. Photo by Rick Ferro.

sky have a slight bluish cast, that may not be objectionable. (But if that bluish cast is symptomatic of a cast that runs through your whole image and makes your portrait subject look blue, that could be a big problem indeed.)

Grays. Like whites, grays that should be neutral in tone (not bluish gray or reddish gray) can reveal overall color casts. Here, the selection of an area to evaluate is much more subjective, though. Paved streets (in most areas) tend to be a reasonably neutral gray. Sometimes clothes and other fabrics are neutral gray (and this can be either light or dark). Shadows on white walls or backdrops are also fairly neutral gray areas.

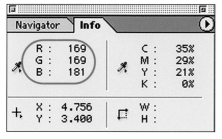

Eyedropper readings of various areas of the cement in the grain silo showed a strong blue cast.

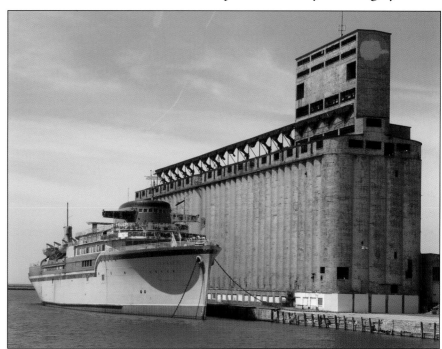

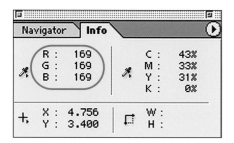

By reducing the blue, the image became better color balanced—and the ship looks much more green, which was its actual color.

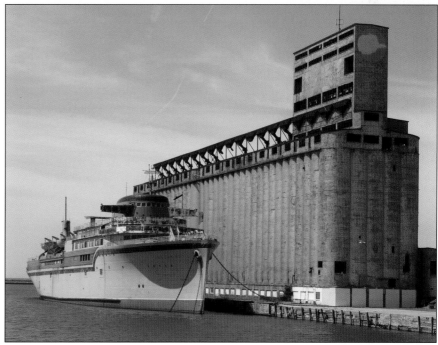

If there are areas in your photo that you know should be neutral gray (or close to it), use the Eyedropper tool and the Info palette to evaluate how close they actually are to neutral. In this evaluation, the R/G/B values can be any value (depending on how light or dark the gray area is), but the individual readings should be close to equal. If one of the readings is different than the other two, you know there's a problem. If all of the readings are vastly different, then you have a bigger problem.

As you use the Eyedropper tool to evaluate your image (assuming you are working on photographs), it pays to move the tool around a bit in the area you are analyzing and look at the overall values and relationships between the R, G, and B channels. Tonal values within even seemingly uniform areas can vary to surprising degrees. Concern yourself with overall patterns (i.e., "The values all seem too low in this area," or "It looks like the red is always a lot higher than the other colors.").

● SKIN TONES

As humans, we are accustomed to seeing human skin tones all around us every day. Therefore, we all notice it pretty quickly when a skin tone just doesn't look right. We notice problems especially quickly in photos of people we know personally or see on a regular basis. Yet, from time to time, we all see images of people who unintentionally look jaundiced, or seasick, or like they've spent too much time in the sun.

There are a few reasons for this. First, skin tones vary widely from person to person, and can change dramatically depending on the lighting, activity level, exposure to sun, and even the person's emotional state. Second, skin tones are also finely detailed and feature hundreds of

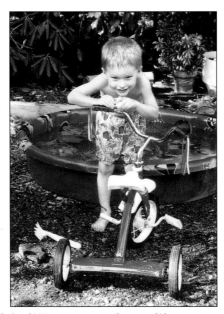

When it comes to skin tones, even subtle differences can be readily apparent. Here, the image on right is much warmer than the one on the left—but it's more noticeable in the skin tones than on the tricycle.

Some of the skin tones here are obviously wrong—but are any of them just right? Getting skin tones to look just right is one of the more challenging problems you'll face when color correcting your images.

shades of color rather than a few unified tones. Third, even subtle problems can be very obvious to viewers. While you can get away with the grass being a little off-color, it's harder for viewers to overlook skin tones that miss the mark.

Because our eyes "help" us by trying to neutralize the subtle color casts that can make our subjects look bad, it is especially important to use the Eyedropper tool when looking at skin tones. Unfortunately, there is no standard by which to judge "correct" color because there *is* no "correct" color. The following guidelines may, however, be a helpful point of departure.

In all cases, you should use your Eyedropper tool to evaluate a median tone on the skin (not a highlight or a shadow). Avoid areas that tend to be pinker (like cheeks, lips, or fingertips) or where there may be

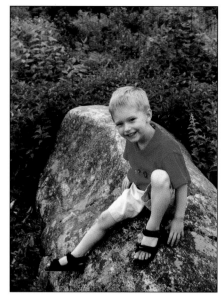
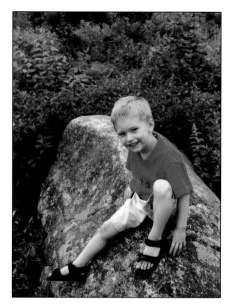

From cool (left), to warm (center), to slightly yellow (right), everyone has their own ideas about how skin tones should look.

light shadows (eyelids, under eyes, knees, under chin, etc.). Good areas may be the forehead or jaw area, shins, forearms, etc. Try to avoid areas where the subject is noticeably tanned (unless the tan is all-over and even). The face is the first thing that most people look at in a portrait, so that's a good place to start.

For fair skinned people in daylight (or daylight-balanced light sources), a good starting point would be in the neighborhood of R=200/G=170/B=150. For darker skinned people in daylight, a good starting point would be in the neighborhood of R=170/G=110/B=80.

Keep in mind, these number are *only for reference*. If you take Eyedropper readings off your subject's face and find that the green and blue values are pretty much in line with those listed above but the red is somewhat higher, think about your subject. Is the person's skin actually a little redder than average? Was he or she blushing or flushed? Was the light warmer than daylight (maybe the photo was taken under the rosy light of sunset)? If so, the color might be right on. If not, consider making an adjustment to the skin tones part of your strategy.

Also, these numbers should be considered proportionately in relation to each other—not as absolute values. Therefore, if your subject's skin-tone readings seem to be more like R=190/G=160/B=140, that's probably just fine, since all of the colors are just proportionately a bit darker.

Finally, in all cases, expect the color readings as you move into darker or more shadowed areas of the skin to become proportionately more blue.

● SETTING YOUR COLOR GOALS

Now that you've examined your image carefully, and hopefully made a few notes on things you'd like to see changed, it's time to set your goals for the image. This might seem obvious—you want it to look "right,"

right? Determining what is "right," however, requires you to make an important decision: should the color match the subject or scene as it was, or should the color be changed to enhance the scene or subject?

In some cases, this decision is made for you. If your image shows a product where the color needs to be correctly reflected, any "enhancements" won't be appreciated. In most other cases, there will be some creative leeway—and often improvements will make the image much more desirable.

Some of the choices you can make to enhance the color in your images will produce subtle (but much appreciated) results. For example, most women will appreciate the evening-out effect of making their skin tones slightly lighter than they actually are, especially when this helps to open up shadows and conceal texture. (In fashion magazines, you'll see the skin tones are often extremely light for this reason). The skin should not, however, look too pink. For portraits of children and babies, on the other hand, people tend to prefer a look that is slightly lighter and more rosy than in a grown-up portrait.

When you have lots of creative freedom, there is no end to the array of special color effects that can be added as enhancements—cross processing, toning, black & white infrared, handcoloring, and other effects are all easy to duplicate using Photoshop instead of traditional materials. These techniques are covered in chapter 11.

Whether strict realism or a more creative interpretation is your goal, it helps to have this end in mind to structure your work and set a definite end point for the image.

All of these images are acceptable renditions of the same portrait. Which one you like best (and which the viewer will like best) is a subjective decision. Photograph by Jeff Hawkins.

6. Automated Tools

Photoshop includes several automated tools for use in adjusting the color correction of your images. While these actually work pretty well in some cases, in almost no case will they be the end-all, be-all solution for an image. Using the automated tools is sort of like taking a picture on a camera without manual aperture, shutter speed, or focus settings. Under perfect conditions, you might get a good shot. The other 99 percent of the time, you'll probably be disappointed.

Still, these tools can be useful for those very few images where they happen to work perfectly. They may also fit the bill in cases where you just want a no-fuss way to make the color look *better* and don't really care if it looks *perfect* (for e-mailing a birthday snapshot to Aunt Jane, for example).

At the end of this chapter, I'll suggest an additional use for these tools that may add value to them even for those of us interested in more controlled color adjustments.

● AUTO LEVELS

To use the Auto Levels, open an image in Photoshop (to see the most dramatic effect, choose one that doesn't already look perfect), and go to Image>Adjustments>Auto Levels. That's it—the change will happen automatically.

The Auto Levels tool basically functions by setting the lightest pixels in each color channel to white, and the darkest pixels in each color channel to black. Intermediate pixels are then distributed proportionately between these two extremes. Because the Auto Levels tool treats each color channel individually, this process can eliminate color casts, but it can also introduce them.

You can expect the best results from Auto Levels when you use an average image (not very light or very dark) that needs a modest adjust-

THIS PROCESS CAN ELIMINATE COLOR CASTS, BUT IT CAN ALSO INTRODUCE THEM.

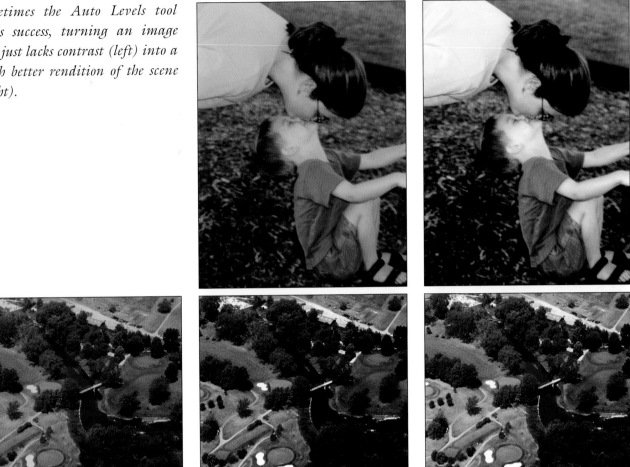

Sometimes the Auto Levels tool yields success, turning an image that just lacks contrast (left) into a much better rendition of the scene (right).

Sometimes the Auto Levels tool makes a bad situation (left) even worse (center) by introducing an unappealing color cast. Using the Auto Contrast tool instead of the Auto Levels gets us around the color cast (right). However, while the color here is better (it's not pink, anyway), there's still a lot of room for improvement.

ment in overall contrast. This tool is not suitable to images that need serious color or contrast correction.

● AUTO CONTRAST

Unlike Auto Levels, the Auto Contrast tool (Image>Adjustments>Auto Contrast) works on all of the color channels collectively. Therefore, it does not correct or introduce color casts to an image. The Auto Contrast tool simply maps the lightest pixels to white and the darkest pixels to black, increasing the contrast of the image.

● AUTO COLOR

The Auto Color (Image>Adjustments>Auto Color) is the most sophisticated of the fully automated tools in Photoshop. Rather than working with the channels, it searches the actual image. Through this process, it identifies and corrects the highlights and shadows and neutralizes the midtones.

If you like using the auto functions but want to tailor the results a bit more, you may find it useful to use custom settings in the Auto Color Correction Options box. (If these settings seem complicated right now, don't worry. They *are* complicated; but they are also not critical at this point, so don't worry if things aren't crystal clear.)

To open the Auto Color Correction dialog box, go to Image> Adjustments>Levels and click on the Options button at the bottom right of the dialog box. The window seen below (here, with the default settings) will appear.

Under Algorithms, you have three choices for defining how you want Photoshop to adjust the overall tonal range of your images. Enhance Monochromatic Contrast preserves overall color relationships while enhancing contrast. Enhance Per Channel Contrast maximizes the tonal range in each channel for a more dramatic increase in contrast, but increases the potential for introducing color casts. Find Dark and Light Colors identifies the average darkest and lightest colors in an image and uses them to maximize contrast.

Clicking on the Snap Neutral Midtones will cause Photoshop to look for a nearly-neutral color somewhere in your image and make that color neutral, adjusting the other tones in the image accordingly.

Moving down in the box, you'll see settings for clipping. In order to increase the contrast of the image using the auto tools, the black and white pixels in an image are clipped—that is, Photoshop ignores a small percentage of either extreme when determining where to set the black

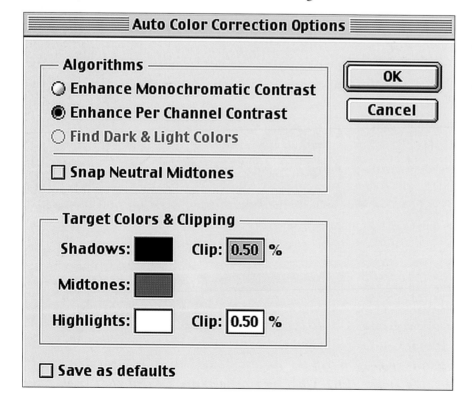

The Auto Color Correction Options dialog box is accessed by hitting the Options button in the Levels dialog box.

point (area of darkest tone) and white point (area of lightest tone) in an image. This ensures that the changes made to the contrast are based on representative tones rather than extreme pixel values. A value between 0.5% and 1% is recommended.

When preparing images for print only (not for viewing on a screen), professional color technicians typically set the highlights and shadows to match the output capabilities of the device that will be used to print them. This is where the Shadows and Highlights settings in the dialog box come into play. Setting these tones accurately allows you to take full advantage of the available printable tones, while avoiding the creation of extremely light whites and dark blacks that can't be printed and, therefore, don't improve the image detail. To experiment with setting different shadow or highlight values, click on the color swatch next to the tone you want to change. This will bring up the Color Picker, allowing you to select the desired tone.

To set your customized selections for use by Auto Levels, Auto Contrast, and Auto Color, click on the Save as Defaults box at the lower left corner, then hit OK.

Images destined for print should have printable highlights that are not pure white. This ensures that there will be no areas of bare paper showing through in the image (left). When the highlights are not controlled (right), the result can be an ugly rendering of white with no details.

The auto tools almost never offer a complete imaging solution when it comes to color and contrast enhancement. They do, however, have one pretty useful function. As you'll recall from chapter 2, when we look at luminous light sources (like a computer monitor) our eyes are constantly balancing the color and contrast of the image for us.

Most people who work on digital images have had a least a few photos that they thought looked great on screen but then looked flat or had a color cast in print. Using the Eyedropper tool is a good way to combat this. Using the auto tools can be another way.

For example, if you're looking at an image on your screen and thinking it looks pretty good, take a second and run the Auto Color, Auto Contrast, or Auto Levels. In a lot of cases, the change will make you see the image in a different way. It may not produce a finalized result, but if you see that adding contrast really helps the image, you can hit Edit>Undo and then increase the contrast exactly as you'd like using a more precise tool. If you run Auto Color and notice that—hey!—the skin tones suddenly look a lot better, you'll know that your "looks pretty good" image still needs some work.

Used in this diagnostic function, you'll find that the auto tools will prove much more useful for identifying color problems than they ever do for actually solving them.

IN A LOT OF CASES, THE CHANGE WILL MAKE YOU SEE THE IMAGE IN A DIFFERENT WAY.

7. Simple Tools

KEEP YOUR EYES OPEN FOR
A PREVIEW CHECKBOX,
AND MAKE SURE IT IS CHECKED.

If you want a middle-ground solution for an image—one that gives you some control, but is still pretty intuitive—Photoshop offers a wide variety of simple color correction/enhancement tools that can be reasonably useful. Some of these are helpful for just about any images, but others will be tools you'll pull out only on special occasions.

As you use each of these tools, keep your eyes open for a Preview checkbox, and make sure it is checked. This will allow you to see the changes you are making as you make them.

● BRIGHTNESS/CONTRAST

The Brightness/Contrast command (Image>Adjustments>Brightness/ Contrast) lets you make simple adjustments in the overall tonal range of

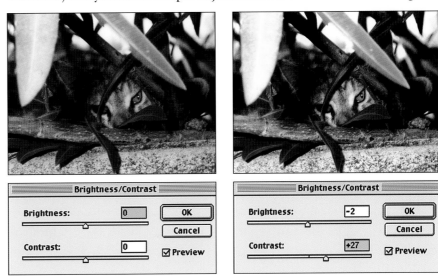

Using the Brightness/Contrast tool is a simple matter of dragging the sliders—to the right to increase contrast and/or brightness and to the left to decrease them.

the image. Unlike the Levels and Curves tools, Brightness/Contrast does not work with individual channels. Another difference is that the changes in contrast are applied to the entire image uniformly, which can result in a loss of detail—you need to use this tool judiciously or you're almost sure to wind up with blocked up (no-detail) shadows and blown-out (no-detail) highlights.

Using the tool is a simple matter of dragging the sliders—to the right to increase contrast and/or brightness, and to the left to decrease them. When you are satisfied, hit OK to apply the changes.

● EQUALIZE

When you apply the Equalize tool (Image>Adjustments>Equalize), Photoshop finds the brightest and darkest tones in the image. It makes the brightest one white and the darkest one black, then evenly redistributes the rest of the pixels in between. The results range from pretty good to totally awful—but it might be worth a try for some images where only very small changes are needed. Adobe suggests it may be useful for an initial correction to scans that look a little darker and flatter than the original image.

THE RESULTS RANGE FROM PRETTY GOOD TO TOTALLY AWFUL.

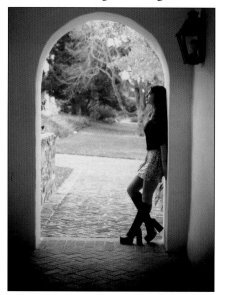 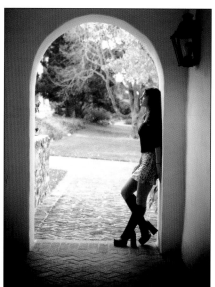

Original image (left) and image after equalization (right). Photo by Jeff Smith.

● VARIATIONS

This tool is one of the most intuitive color-correction tools in Photoshop. Using it, you can easily correct many color-balance problems in your photographs. Because it allows you to make your own judgments about how an image should look, it is much more flexible than the auto tools (Auto Contrast, Auto Levels, and Auto Color), yet almost as easy to use.

To use Variations, go to Image>Adjustments>Variations. Doing this will open a dialog box like the one shown on the facing page. Normally,

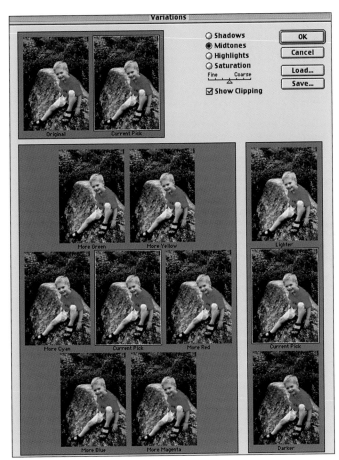

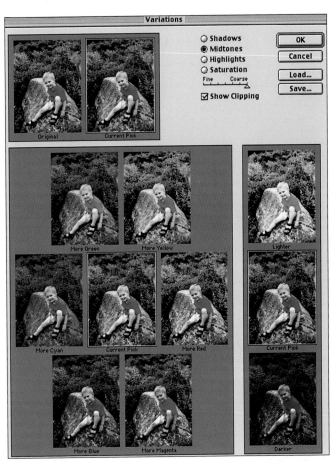

The Variations dialog box shows numerous previews of possible image changes—More Green, More Blue, Darker, etc. By clicking on one or more of these previews, you can change your original image as you like. The effect of this change is displayed immediately in the current-pick version of the image.

By moving the slider in the upper right of the dialog box, you can adjust how great a difference you'll make with each change you apply. Here, the slider was set to Coarse. As you can see, the changes are much more dramatic than in the dialog box shown on the left, where the slider was set to the midpoint.

you should begin with the Midtones radio button selected. This will allow you to make corrections to the tones that make up the bulk of the image. If you like, you can then select the Highlights, Shadows, or Saturation buttons and experiment with their respective effects on your photograph.

Near the top of the box, there is a slider that runs from Fine to Coarse. This allows you to control how great a difference you'll make with each change you apply. Start with this set at the midpoint. As you apply changes, you may find that you want to make increasingly fine adjustments. In this case, simply move the slider to the left.

At the top left of the dialog box, your original image appears. This is a handy reference. If you ever decide that the changes you have made aren't helping, you can click on this image to start over.

Next to the original image, the current pick appears. The current pick also appears in the center of the color-balance samples (the cluster of seven images), and in the middle of the lighter/darker examples (the

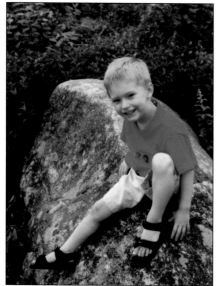 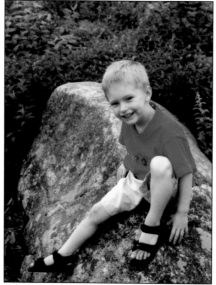

This image is a bit too dark and a little too red. Notice how the little boy's skin looks like he's been out in the sun much too long. Also, the rock the boy is seated on looks pink and the foliage in the background is a bit brown.

Using the Variations tool, blue and green were added to the image and the photograph was made a little lighter. This made a big improvement throughout the frame—in the skin tones, rock, and foliage.

stack of three images). The current pick shows the results and is updated with every adjustment.

To begin making changes, simply click on the preview image that you think looks best (perhaps "More Green" or "Lighter"). This will automatically update the current-pick preview, so you can see the results. You can apply as many changes as you like by clicking on one preview image after another. For some basic guidance on how to adjust the color balance in your images, consult the chart below.

TO BEGIN MAKING CHANGES, CLICK ON THE PREVIEW IMAGE THAT YOU THINK LOOKS BEST.

IMAGE IS:	CLICK ON:
too blue	more yellow
too green	more magenta
too red	more cyan, more green
too cyan	more magenta, more red
too magenta	more green, more yellow
too yellow	more blue

● COLOR BALANCE

Used for making general corrections to an image, the Color Balance command (Image>Adjustments>Color Balance) allows you to change the overall mix of colors. Using the sliders in the Color Balance dialog box, you can adjust three pair of complementary-color balances: cyan–red, magenta–green, and yellow–blue. Do these pairings of colors

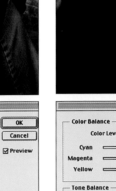

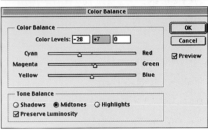

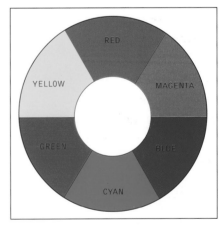

ABOVE: *The Color Balance tool is useful for correcting color casts. In the photo and screen shot on the left, the image is a bit pink. Adjusting the sliders produced a better color balance (right photo and screen shot). Photo by Jeff Smith.* RIGHT: *The sliders in the Color Balance dialog box move between complementary colors—the colors opposite each other on the color wheel.*

sound familiar? They should—the color sliders move between complementary colors (see the diagram above if you need a quick review). Adding yellow reduces the appearance of blue (and vice versa); adding green reduces the appearance of magenta (and vice versa); adding red reduces the appearance of cyan (and vice versa). In the example at the top of the page, the image looked a little too red and very slightly too magenta. To compensate, the cyan–red slider was moved toward cyan (reducing red), and the magenta–green slider was moved toward green (reducing magenta).

As you saw in the Variations command, the Color Balance tool allows you to confine your changes to the highlights, midtones, or shadows. This can be useful if, for example, the color balance looks great

everywhere except in some shadow areas that look a little too blue (something that often occurs when images are taken under a blue sky.

In most cases, you will want to check (activate) the Preserve Luminosity box. This preserves the luminosity (the lightness or darkness of the tonal values) as you make changes in the color, preventing your image from looking darker or lighter when you've finished the change.

● SELECTIVE COLOR

With the Selective Color tool (Image>Adjustments>Selective Color), your control over your image grows by leaps and bounds! Rather than applying changes universally to the entire image, this tool allows you to apply it selectively to one color. In the Selective Color dialog box, you'll find a pull-down Colors menu that allows you to select reds, yellows, greens, cyans, blues, magentas, whites, neutrals, or blacks.

Once you've selected the color that you want to adjust, it's a simple matter to click and drag on the sliders beneath the color menu and observe the changes as they happen. When you are satisfied, just hit OK to apply the adjustment.

This method works best when you want to make a subtle adjustment—this isn't the method to use when you want to change one color to another, for example.

In the Selective Color dialog box, you can select the color you want to adjust.

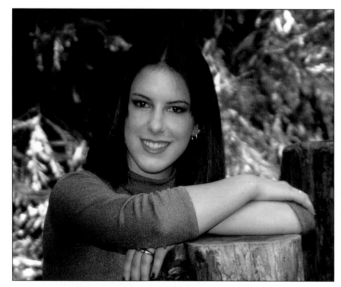

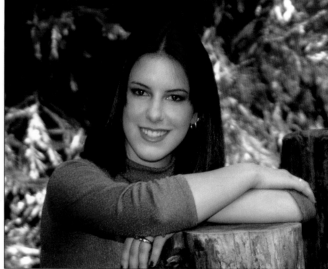

The greens in the image above seemed like they could use a little boost. The first step was to open the Selective Color dialog box (left).

After selecting green from the Colors menu, the sliders were adjusted until the colors seemed more vibrant. Photo by Jeff Smith.

Keep in mind, as well, that the entries in the Colors pull-down menu are plural for a reason (blue*s*, red*s*, etc.). This means that any changes you make will apply to *all* instances of that color within the frame. So, if you change the tone of your subject's red shirt, you'll also change any red tones in her lips, cheeks, nail polish, etc.—as well as any reds that happen to be in the background. The areas of your image that Photoshop identifies as "red" may include areas that seem more like magenta or orange to you, as well. Therefore, you need to carefully evaluate each change to make sure that what benefits one aspect of the image does not detract from another.

Digital images sometimes exhibit a bluish cast in the whites (left). The Selective Color tool works well to eliminate this (right). Photo by Jeff Hawkins.

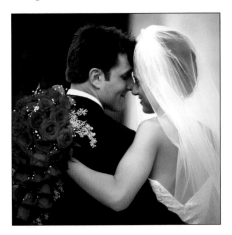

The Selective Color tool works wonders in one specific instance. In images shot on a digital camera, whites sometimes have a tendency to drift off into blue. This is usually most obvious where lighter highlight areas start to fade off into shadows. To correct the problem in one simple step, select white from the Colors pull-down menu and reduce the cyan until the bluish cast is neutralized (don't go too far, though, or your whites will exhibit a yellowish or pinkish cast that's even less appealing!). If the light shadows still seem a little bluish, you can select cyan or blue from the Colors pull-down menu and reduce the cyan slider setting a bit—but keep an eye on other blues in the frame as you do this!

● HUE/SATURATION

As the name suggests, the Hue/Saturation tool (Image>Adjustments>Hue/Saturation) allows you to adjust the hue (the color) and the saturation (the purity or intensity) of all of the colors in an image or to select

In the Hue/Saturation dialog box, you can select color components from the Edit pull-down menu. To perform universal changes on all the colors, select Master.

color components. You can select what aspects of an image you want to change using the Edit pull-down menu at the top of the Hue/Saturation dialog box. If you want to make universal adjustments to all the colors in an image, select Master. A good place to start with this tool is to make Master changes, since this makes it very easy to see exactly what is happening.

As you move down the dialog box, you'll see three sliders. The top slider adjusts the hue of the image (or image component). The middle slider adjusts the saturation of that color. The bottom slider adjusts the lightness (brightness or darkness) of the image or image component.

Below the slider, you'll see two gradient bars. These represent the colors in their order on the color wheel (see page 51). The upper color bar shows the color before the adjustment; the lower bar shows how the adjustment affects all of the hues at full saturation. If you look at the center screen shot at the bottom of this page, you'll see that the bottom gradient bar has shifted, reflecting the color alteration made using the hue slider at the top of the dialog box.

If you think back to the Selective Color tool, you'll recall that one of its primary limitations was the fact that each of the colors to which

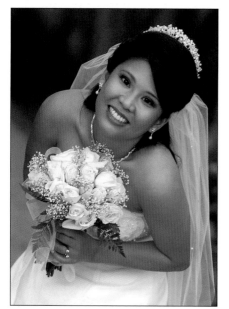

The first step is to open the Hue> Saturation dialog box. Photo by Jeff Hawkins.

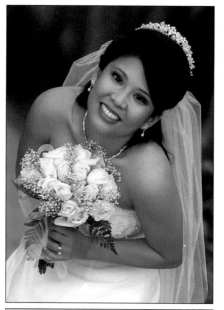

With Master set in the Edit field, the hue slider affects all of the tones in the image.

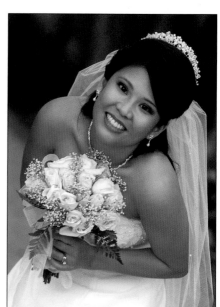

Reducing the saturation creates an image with more subdued renderings of each color.

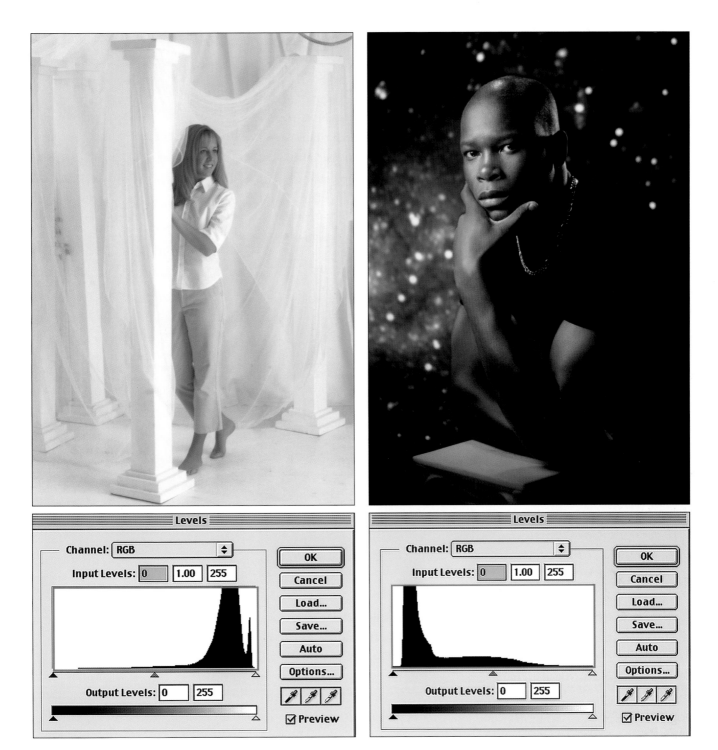

These images are paired with a screen shot of their Levels dialog box. As you can see, the histograms are very different for these images. Photographs by Jeff Smith.

tall near the highlight end of the histogram. That tells us that most of the tones in this image are pretty bright. Notice the height of the histogram over the midtone slider—pretty low. This tells us that very few of the tones in the image fall into this category. Now, look at the histogram above the black slider. As you can see, there's nothing there; none of the tones in this image are pure black. Just by evaluating the histogram, you can see one quality of this image that might need attention.

If you look at the second image, you'll see that quite the opposite is true. The histogram in the region of the black slider is very high, and

quite a few tones also fall into the midtone category. Looking at the histogram over the white slider, you can see that a very small number of tones in the image (the bright stars in the background) extend up to this brightness. Even if you didn't have the image to look at, you could tell just by looking at the histograms that this is an image with predominantly dark tones, that some tones are a bit lighter, and that a very small amount of the image is made up of very light tones.

In most images, you'll see that the data is more evenly distributed across the entire range of the histogram, as seen in the photo below and the screen shot to the right of it.

In most images, you'll see that the data is more evenly distributed across the entire range of the histogram. Compare this image and histogram with the ones on the previous page. Photograph by Jeff Smith.

Before we go on to making corrections with the Levels command, let's look at a few more examples of how the histograms can help you diagnose image problems—even if you don't end up using the Levels to fix them.

Revealing Contrast. The overall tonal range and contrast of an image is sometimes easier to evaluate objectively using the Levels histogram. In the example in the center (facing page), the low contrast of the photograph is obvious in the histogram, which shows that the tonal range of the image does not extend as much as it could into either the black or the white range. In some cases (as discussed on page 27), this may be done intentionally to match the image to the printable range of an output device. Unless this is the case, you'd probably want to consider strategies for improving the contrast of such an image.

In the photograph and screen shot on the right, you see the opposite scenario—here the contrast is so high that the highlights are completely blown out and the shadows are completely blocked up (neither have detail). If you look at the histogram, you can see this represented

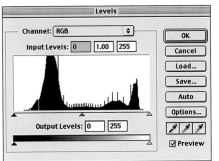
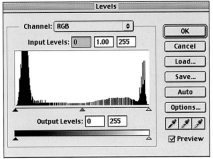

ABOVE: *Original portrait by Jeff Smith.* CENTER (TOP AND BOTTOM): *A low-contrast version of the photo and its histogram.* RIGHT (TOP AND BOTTOM): *A high contrast version of the photo and its histogram.*

graphically. The histogram has spikes in both the black and white ranges and doesn't taper off smoothly at the extreme edges of the histogram. This indicates that there are large areas of extremely dark black and extremely bright white—probably not what you want to see in most images.

● SLIDERS
As was previously noted, beneath the histograms are the Levels sliders. On the left is the black shadow slider, located under the area of the histogram that shows dark tones. In the center is the gray midtone slider, which appears under the area of the histogram that shows the midtones. On the right is the white highlight slider, found under the highlight area of the histogram. These sliders can be clicked and dragged to change the tonal balance of the image.

Improving Contrast. Let's look at an example. Above, we saw an image that was lacking in contrast. As we noticed, the histogram showed that the image data did not extend out to the deep shadow range (over the black slider) or the bright highlight area (over the white slider). As demonstrated in the images on the next page, a simple fix for this would be to drag the shadow slider to the left until it is just under the edge of the far-left histogram data. This will set the tones in that range (the

darkest tones in the image) to black. Then, drag the white slider to the right until it is just under the edge of the far-right histogram data. This will set the tones in that range (the lightest tones in the image) to white. You can see this change demonstrated in the center screen shot above.

The result of these steps will be an increase in the contrast of the image—but at a bit of a cost. To see the price paid, click OK to apply the changes made to the sliders. Then return to Image>Adjustments> Levels to reopen the dialog box. When you do so, you will see that the histogram for the image now extends from pure black to pure white (see the screen shot on the right). However, while moving the sliders to increase the contrast forced the data to fill the entire tonal range, it also caused little gaps to appear in the histogram. Looking at the histogram, you can see that for some tones, there is no image data (there's a gap in the histogram). This means that the transition between some tones in the image may not be perfectly smooth. When this occurs, evaluate the image carefully and use your judgment as to whether the results are perceptible. If they are, you can always go to Edit>Undo and try a different tool (such as the Curves, as discussed in chapter 9) for improving contrast.

Adjusting the Midtones. For many photos, a simple adjustment to the midtones can make a big improvement. This is very easy to do in the

LEFT (TOP AND BOTTOM): *The photograph lacks contrast, as revealed by the histogram.* CENTER (TOP AND BOTTOM): *Moving the shadow and highlight sliders in under the histogram data improves the contrast.* RIGHT (TOP AND BOTTOM): *As a result of this change, the image has better contrast—but note the small gaps in the histogram.*

Levels dialog box. To brighten the midtones in an image, go to Image> Adjustments>Levels. Then, click on the midtone slider and drag it toward the black point slider. This may seem counterintuitive—wouldn't you want to drag it toward the highlight to brighten the image? Nope. Remember, the slider you are moving defines the midtone point. When you move it toward the shadow slider, you shift the tones in the image so that more of them are lighter than the midtone (i.e., more of

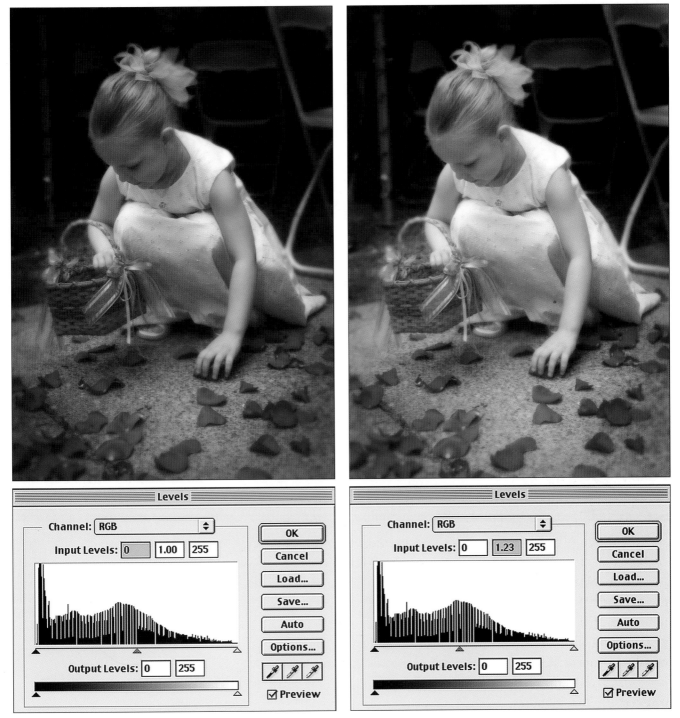

The image on the left is a little dark. Moving the midtone slider to the left slightly brightens the midtones (right). Notice that the midtone reading in the Input Levels reflects this change, going from 1.00 to 1.23.

the histogram lays between the midtone slider and the white point slider than between the midtone slider and the black point slider). To darken the midtones in an image, simply move the midtone slider toward the white point slider.

● EYEDROPPERS

The eyedroppers provide a quick way to remove color casts and set the overall tonal range of your image. To use them, open an image and go to Image>Adjustments>Levels. You can use one, two, or all three of the eyedroppers, depending on your needs.

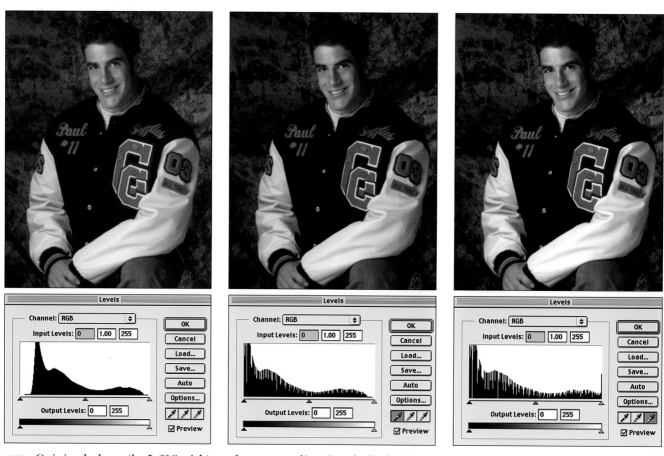

LEFT: *Original photo (by Jeff Smith) and corresponding Levels dialog box.* CENTER: *Setting the black point with the Set-Black-Point eyedropper (note the change in the histogram).* RIGHT: *Setting the white point with the Set-White-Point eyedropper.*

To use the Set Black Point eyedropper, simply click on its icon at the lower right of the dialog box (see page 62). Your cursor will then turn into an eyedropper. Move the eyedropper over the image and click on an area of the image that you want to become pure black. Assuming you have the Preview box checked (at the lower right corner of the dialog box), the image will change instantly to reflect the change. Don't worry if it doesn't look right—you can click again and again until you get it right. Be careful with this tool; you can easily create ugly, blocked-up areas of black with no detail.

You follow the same procedure to use the Set White Point eyedropper, clicking on an area of the image that you want to be pure white. If there's not a clear choice (light a bright specular highlight), click around on the image until you find the best choice. Be careful to avoid creating ugly areas of pure white highlight with no detail. You'll probably also see the overall color change with each click, because the colors in the image shift as the clicked-on area is neutralized to pure white.

Whether or not you will want to use the Set Gray Point eyedropper will depend on the image. If there is no pure gray tone in the image, clicking with this tool will cause some big color shifts (remember, this eyedropper sets the *gray* point, not just a *midtone* point). In this image, the buttons on the young man's jacket are a neutral gray, so clicking on a darker area of the surface of one button provided a good result and neutralized a slightly pink color cast.

The eyedroppers won't provide a solution to every problem but can be a very useful tool when applied selectively. Keep in mind, you can always hit Cancel (or go to Edit>Undo) if you decide you're not improving the look of the image.

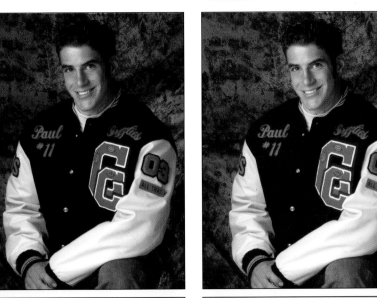

LEFT: *Setting the gray point with the Set Gray Point eyedropper.* RIGHT: *Adjusting the midtone slider to slightly brighten the midtones completes the correction, yielding an image with much better color and contrast.*

● CHANNELS

As we saw on page 61, the Channels pull-down menu at the top of the Levels dialog box allows you to work on the image as a whole (the composite channel) or on individual channels one at a time. This can be very useful for making overall color changes to an image in order to boost the contrast and/or remove a color cast. The basic procedure is easy to accomplish and can be adjusted visually to suit the individual image.

To begin, open an image in the RGB color mode. Keep in mind that you'll be able to see the changes most clearly if you work with an image that doesn't look perfect already (see next page). You may also need to adjust your manipulations of the channels if your original image has a preponderance of tones in one color. As with all color corrections, your critical eye must be the final judge of success.

After going to Image>Adjustments>Levels, pull down on the Channels menu at the top of the box and select the red channel. Move the highlight slider to the left until it is just under the edge of the data in the histogram. Then, move the shadow slider to the right until it is just under the edge of the image data in the histogram. Repeat this process for each channel (see the screen shots under each of the images to the right). As you make each change, don't worry if the colors seem to shift in unpleasant ways; you can only see the final effect when you've completed the last change on the last channel.

When you have completed this process, your image (in most cases) should be better color balanced and have better contrast. Evaluate your image carefully, however, to ensure that the highlights are not blown out (lacking detail) and the shadows are not blocked up (lacking detail)—unless you intend the image to look that way. If the color in your image doesn't look right, you may also want to try making adjustments to the midtone sliders in one or more of the individual color channels.

In the next chapter, you'll learn about an even more powerful color-correction tool, and the one preferred by most professionals: the Curves.

Adjusting the sliders in each channel can eliminate color casts while increasing contrast.

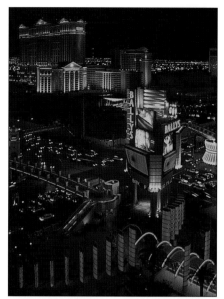

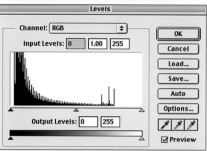

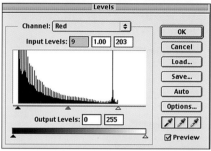

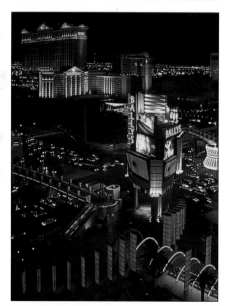

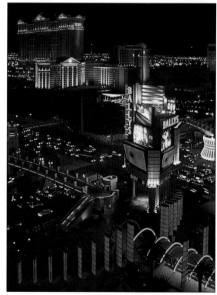

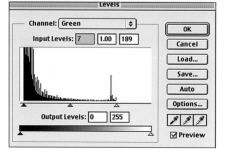

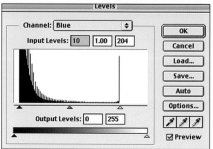

9. Curves

What is it that makes the Curves the choice of professional image editors for adjusting color? The answer is simple: control. As you've seen in the previous chapter, the Levels tool is quite powerful but allows you only three points of control per channel (the shadow, midtone, and highlight sliders). The Curves tool, on the other hand, allows you to establish up to *fourteen* points of control—although using more than five is pretty rare. As you can imagine, this allows you to make much finer adjustments and to manipulate your images in ways that are impossible with any of Photoshop's other tools.

The Curves dialog box.

● THE DIALOG BOX

Many of the features of the Curves dialog box are identical to those in the Levels dialog box. For these (noted below) you can refer back to the descriptions in the previous chapter.

Curve. The diagonal line running through the central area of the dialog box (1) is called the curve. It might seem odd to call a straight line a curve, but as you'll see, it is the bends you apply to this line that will change and enhance the color in your image.

Tonal Gradient. The gradient bars at the bottom and left of the curve (2) represent the tones con-

trolled by the proximate area of the curve. In the RGB mode, as seen on the previous page, the dark tones are controlled by the lower part of the curve. The light tones are controlled by the upper part of the curve. As you move from the bottom left to the top right, therefore, the tones controlled by the curve transition from pure black, through the mid-tones, to pure white at the top right-hand corner. If, for some reason, you'd like to reverse this, click on the black and white arrows in the center of the bottom gradient bar.

Channels. As in the Levels dialog box, the Channels pull-down menu (3) allows you to access the individual color channels for the image.

Input and Output. For each point you add to adjust the curve, you'll see an input and output reading in the boxes at the bottom of the dialog box (4). These readings show the current value for the cursor position as you place and move points.

Edit or Draw Curves. To change the tones in your images using the Curves tool, you will generally want to click and drag on the curve line (5) to change its position. If you prefer to draw the curve manually using your cursor, click on the pencil icon at the lower right of the dialog box (6), then manually draw a curve over part or all of the existing curve in the center of the dialog box. You'll need a steady hand to accomplish this.

Resize the Dialog Box. Because you may want to make very fine adjustments to the points that create the bends in your curve, Photoshop allows you to enlarge the dialog box by clicking on a box at the lower right corner of the dialog box (7).

Preview. Make sure that this box (8) is checked as you work on your image so that you'll instantly be able to see the results of the changes you are making.

Eyedroppers. The three eyedroppers (9) function the same as with the Levels tool. See pages 68–69 for more on this topic.

Options. The Options button (10) gives you access to the Auto Color Correction Options settings. See page 44 for more on this topic.

Auto. Clicking this button (11) provides an automated correction of the image.

Smooth. If you choose to draw a curve manually, the Smooth button (12) will become active. Clicking on it will smooth the curve you draw, providing a more seamless transition between the various tones in the image.

Save and Load. The Save (13) and Load (14) buttons allow you to make settings to the Curves, then save them for later use. To access the saved settings for a second image, open that image and go to Image>Adjustments>Curves, click the Load button, and identify the previously saved settings.

YOU WILL GENERALLY WANT TO CLICK AND DRAG ON THE CURVE LINE TO CHANGE ITS POSITION.

Unlike the Levels tool, the dialog box for the Curves tool will look the same every time you open it. Since it will not, therefore, provide any information about the tonal balance of the image, it is especially important that you've already determined your goals for the image before you begin manipulating the curves. For a review of this preflight process, see chapter 5.

Smoothness and Steepness. There are two important ideas to keep in mind as you begin to work with the Curves tool. First, the smoother you keep the curve itself, the better your results will look. You can create sharp bends and tight turns, but these will change the tonalities in ways that are not realistic and are generally not aesthetically pleasing.

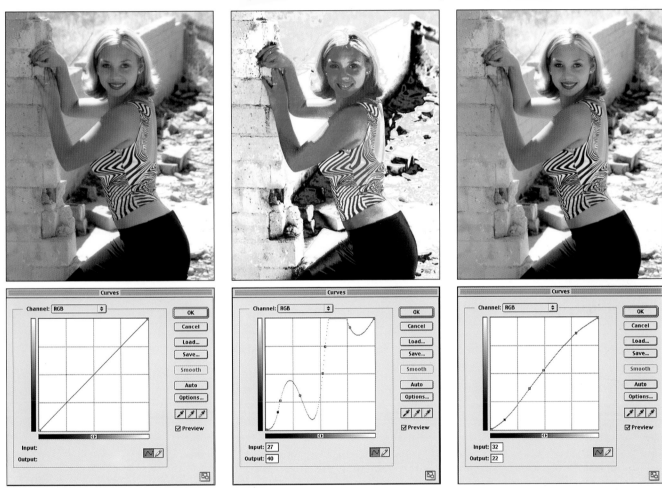

LEFT: *Original photo by Jeff Smith. The screen shot below it shows the unedited straight-line curve.* CENTER: *When you adjust the curve in ways that produce sharp turns (although this is certainly an extreme example), the results will not look natural.* RIGHT: *Shallow, smooth bends in the curve line should be the goal, since these produce the smoothest transitions between the tones in the image.*

Second, when you make the curve more steep than the 45° angle at which it starts, the result will be an increase in contrast. When you make the curve flatter or more shallow, the result will be a decrease in contrast. As you edit a single curve, making one area more steep (more con-

trasty) will often result in other areas becoming more shallow (less con-trasty), so you'll need to evaluate the curve and the image carefully to ensure you are happy with whatever trade-offs there may be.

Adjusting the Midtones. Let's begin by looking at one of the most basic changes: an adjustment to the midtones of an image. In the screen shot under the bridal portrait below (left) you can see the original straight line of the curve. By clicking on the midpoint of the line and dragging it down, the midtones in the image are made darker (center image and screen shot). Conversely, by clicking on the midpoint of the line and dragging it up, the midtones in the image are made lighter (right image and screen shot).

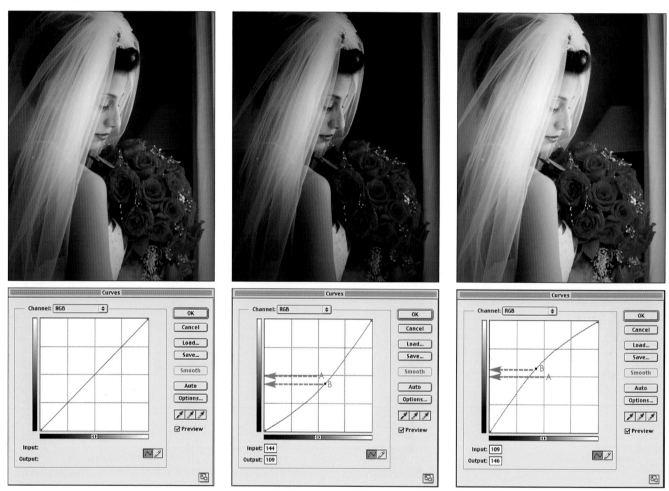

LEFT: *Original image by Jeff Hawkins. The screen shot below it shows the unedited straight-line curve.* CENTER: *Pulling down on the center of the RGB composite curve (from its original position at point A to its new position at point B) darkens the midtones. Looking at the gradient bar next to the arrows, you can see this change in tonality.* RIGHT: *Pulling up on the center of the RGB composite curve (from its original position at point A to its new position at point B) lightens the midtones. Looking at the gradient bar next to the arrows, you can see this change in tonality.*

Even without looking at the photo, carefully evaluating the curve itself could tell you what to expect in terms of tonal changes in the image. Looking at the center screen shot above, you can see that the

The History Brush Source icon was set to a previous state in the History palette.

pink. Although this change would definitely be considered an optional one, the same process can be used in any situation where getting one area of color looking right seems to compromise another area of color.

In this case, we'll use the History Brush to "paint" the data from the earlier version of the image onto the current version. To use the History Brush, locate the History palette on your screen (Window> History). In the palette (shown to the left), click once to activate the history state onto which you want to paint (probably the bottom one in the list—the most recent version of the image).

Then, click to activate the History Brush Source icon for the state from which you want to paint. (This is the brush with the arrow and dotted line around it. Its default position is next to the original image state at the top of the palette above the double line.)

Select the History Brush from the toolbar and choose a soft brush, tailoring the size to the area you want to paint. Finally, click and drag over the area you want to paint, applying the data from the source state to the selected state. In this case, the purply pink of a previous incarnation of the flowers was painted back onto them.

When you've finished your local corrections, you can evaluate the image one last time and decide if there are any additional enhancements

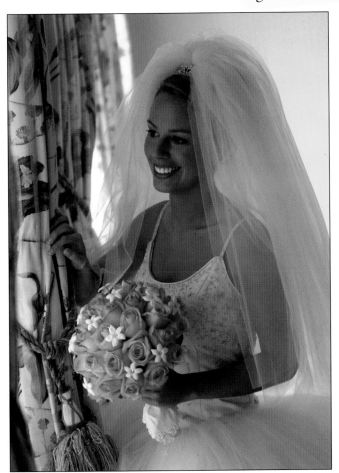
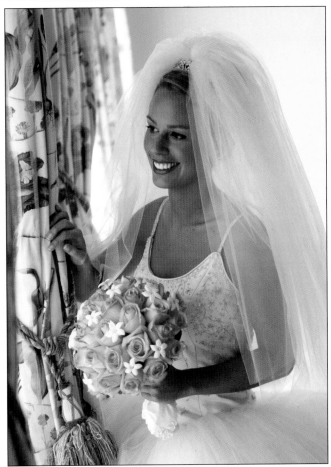

LEFT: *Image before color correction.* RIGHT: *Image after color correction.*

you'd like to make. Perhaps you'll want to add a vignette or use a filter to create a painterly effect. Don't be afraid to zoom in close and study the colors.

● PRACTICAL EXAMPLE: HAZY BACKGROUND

Preflight. Here's a pretty common problem: part of the image seems to look good (here, the foreground), but the rest of the image (here, the background) looks, well, not so good. The water and trees behind these cows are totally flat and dull. Before deciding not to make any global changes, though, it's a good idea to take a look at the image histogram by opening the Levels dialog box.

LEFT: *The original image.* ABOVE: *The histogram for the original image.*

Opening up the Levels dialog box and looking at the histogram (above right) seemed to confirm the above analysis. There was a pretty good distribution of tones, and the problems with the image might be isolated to the background. Still, it never hurts to reevaluate the foreground after making the needed corrections to the background.

Local Corrections with Adjustment Layers. Adjustment layers are really a wonderful tool for color correction. First, because they isolate the changes on a separate layer, they make it easy to adjust the intensity of the change by increasing or decreasing the opacity of the layer. Second, when you make your color changes on an adjustment layer, the settings you choose are retained so that you can go back and tweak them at any time. Finally, adjustment layers work very well for making local changes, since you can limit the changes to a selected area and make sure that the updated image data blends seamlessly with the unaltered image data.

In this case, since only the background of the image needed to be adjusted, it was selected using the Magic Wand (perfect for selecting the water since it's all one color) and the Marquee tool (used to select the areas above the water). The Lasso tool was used to clean up the selection, which was then feathered two pixels (Select>Feather). This helped to ensure that the selected area would blend well with the underlying

The new adjustment layer is highlighted here at the top of the Layers palette. To reopen and adjust the tool used on the layer (Curves, Levels, etc.) double click on the black and white circle icon just to the left of the chain icon.

image after it was corrected. At this point, the selection was saved (Select>Save Selection) so that it could not be accidentally deactivated and lost. If you decide to save any selections during the process of editing an image, be sure to go to the Channels menu and delete the new alpha channels this creates before outputting the image.

With the selection still active, a new adjustment layer was created by going to Layer>New Adjustment Layer>Curves. (If you'd prefer to use any other of the color correction tools, you can select something other than Curves from the pull-down menu.)

Creating this new adjustment layer automatically opens the Curves dialog box, but now it will work only on the selected area of your image. Since the background area needed to be darker, an anchor point was created at the center of the curve line and pulled down. To add the needed contrast to the background area, a second anchor point was added in the three-quarter tone area of the line and pulled down.

ABOVE: *The initial change to the curve.* RIGHT: *The change in the image.*

The background area still seemed like it could blend a little better with the foreground; it still seemed hazy. To correct for this, the Curves dialog box was reopened and the blue channel selected. Pulling down on the center of this curve helped the color balance in the background.

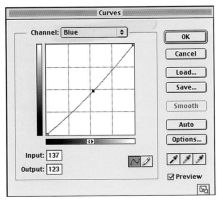

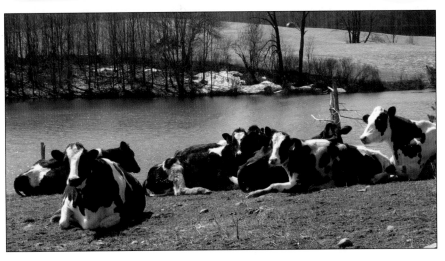

ABOVE: *The second change to the curve.* RIGHT: *The change in the image.*

Second Image Evaluation. The image looked a lot more balanced after the changes made to the adjustment layer. Therefore, it was time to take a last look at the image as a whole and decide if any additional changes were needed.

The only nagging concern seems to be that the shadow areas on the cows don't have the best detail. It's hard to see their eyes. This was a factor of the original exposure; in the bright sunlight, it was a choice between blowing out the highlights or blocking up the shadows. Still the detail that did make it into the shadows could be enhanced slightly by using the Dodge tool.

That done, the image is complete—and shows a big improvement over the original.

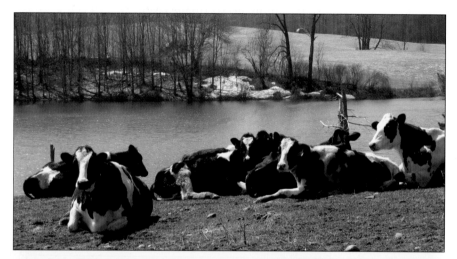

TOP: *The original image.* BOTTOM: *The corrected image.*

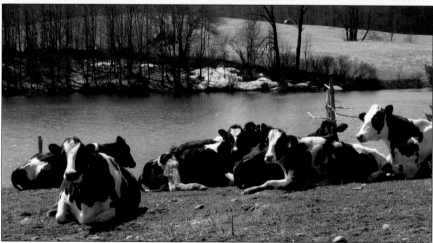

● PRACTICAL EXAMPLE: FADED PHOTO

Preflight. We probably all have old family photos that are faded and yellowed. Sometimes, the fading is part of the appeal of the image, but more often some color enhancement can help to bring out details that are on the path to being lost forever.

The image on the facing page was made in 1908. It's a contact print made on photo-postcard paper. The note on the back says, "We shot

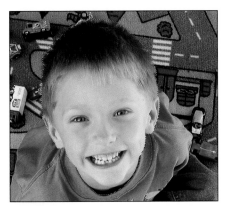

The boy's face was selected using the Lasso tool.

The selection was then feathered by two pixels.

If you like, you can select a name for the new adjustment layer in the New Layer dialog box.

per. After clicking on a medium-toned area in one of the roads to neutralize the blue cast, the Set Black Point eyedropper was also used to click on one of the shadowed areas of the cars to help the contrast a bit.

Second Image Evaluation. With the eyedropper corrections completed, things were looking up for this looking-up image. However, while the colors on the background looked much better, the adjustments are probably a little bit too harsh on the little boy's skin tones. His face looks a bit too yellow and has a tiny bit more contrast than is really needed.

Local Corrections with Adjustment Layers. To begin, the boy's face was selected using the Lasso tool. Then, this selection was feathered by two pixels (Select>Feather). This helped the adjustments made to this selected area to blend seamlessly with the areas around them. At this point, the selection was saved (just in case) by going to Select>Save Selection and naming the new channel.

To apply an adjustment layer to the selected area, go to Layer>New Adjustment Layer and select the tool you want to use from the pull-down menu. In this case, Curves was selected. Doing this opens up the New Layer dialog box, where you can enter a name for the new layer. For complicated jobs where you may be using several adjustment layers, naming each one can make it a lot easier to navigate in your Layers palette and reduce the risk of making adjustments to the wrong layer.

After the name of the layer was entered, the Curves dialog box appeared, and adjustments were made to the blue channel (increasing it in the midtones to reduce the yellow cast), the red channel (reducing it

ABOVE: *Pulling up on the blue curve reduced the yellow cast in the boy's face because blue is the complement of yellow.* TOP RIGHT: *A slight red cast still remained, so the red curve was pulled down very slightly.* RIGHT: *Finally, a very shallow S-curve was created in the curve for the composite channel to very slightly reduce the contrast.*

very slightly), and to the composite channel (creating a shallow inversed S-curve to reduce the contrast slightly).

When this was completed, the boy's face looked a lot better—but the correction seemed to have taken things a little bit too far. That's the great thing about using adjustment layers though. To reduce the effect of the adjustment, you can simply reduce the opacity of the adjustment layer in the Layers palette. In this case, setting the layer opacity to 80% seemed to do the trick, creating a less yellow and contrasty tone but still leaving the skin tones looking warm and vibrant.

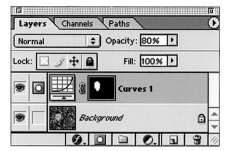

The opacity of the adjustment layer was set to 80%.

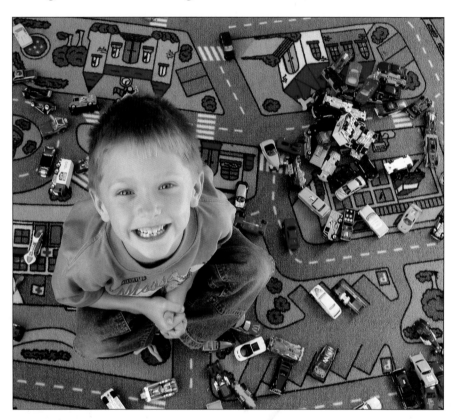

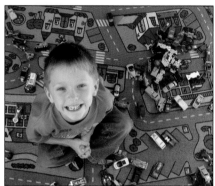

TOP: *The original image.* LEFT: *The corrected image.*

● PRACTICAL EXAMPLE: UNDEREXPOSURE

Preflight. When shooting this photo of the stern of a beached ship (facing page), the exposure was metered for the sky in order to keep detail in this very light area. In this particular situation, this was an easy exposure decision because the ship, while a little dark, did not lose detail and it was clear that the overall exposure could be balanced after the fact using Photoshop.

That said, the challenge with this image was to keep the detail in the sky while lightening the underexposed stern of the ship and making it more the focal point. The contrast on the ship was also a little low, so that issue also needed to be addressed in the adjustments. Finally, the paint on the lower part of the stern was actually red, a detail that is so subdued due to the underexposure that it is almost invisible.

Global and Local Changes with Layer Modes. Sometimes, duplicating the background layer and making adjustments to the mode of the

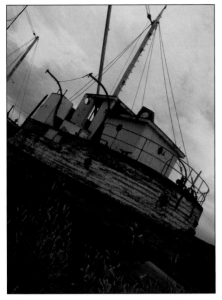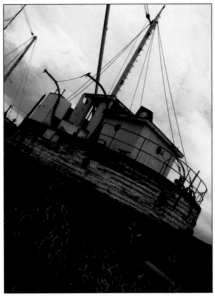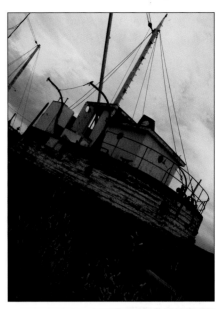

LEFT: *Original image.* CENTER: *The background layer was duplicated and, at the top of the Layers palette, the mode of the overlying layer was set to the Overlay mode.* RIGHT: *Here, the overlying layer was set to the Soft Light mode, which preserved more of details in the shadow areas, since it did not increase the contrast so dramatically.*

overlying layer can make a big change in your image. The mode of the layer affects the way that the data in the layer interacts with the data on the underlying layer. This is usually not the last step you'll want to make when correcting an image, but it can sometimes be a useful intermediate step.

In this case, the Overlay mode and the Soft Light mode both looked pretty good, but the Soft Light mode seemed to preserve a little more

An overview of the layer modes, describing the degree and type of interaction that occurs between the layer set to this mode and the underlying layer.

NORMAL—No change takes place.

DISSOLVE—Pixels scatter based on their transparency.

MULTIPLY—The mathematical value of the top layer is multiplied by that of the bottom layer(s).

SCREEN—The mathematical value of the top layer is added to that of the bottom layer(s).

OVERLAY—Light areas in the top layer are "screened" (see above), dark layers are "multiplied" (see above).

SOFT LIGHT—Based on the overlying layer, treats black as burning and white as dodging.

HARD LIGHT—Very similar to the Overlay mode.

COLOR DODGE—Similar to both Screen and Lighten, tends to lighten images.

COLOR BURN—Like Color Dodge, but darkens images.

DARKEN—Chooses the darkest values of the affected pixels.

LIGHTEN—Chooses the lightest values of the affected pixels.

DIFFERENCE—Displays the difference between the top and bottom pixels based on their hue and brightness.

EXCLUSION—Inverts colors in the underlying area based on the lighter areas in the layer above.

HUE—Alters the color of the layer without affecting the brightness or saturation.

SATURATION—Saturation of the upper layer replaces that of the lower level.

COLOR—Colors of upper level replace colors of lower level, while brightness remains constant.

LUMINOSITY—Retains underlying layer's color and saturation while basing brightness on the upper layer.

detail on the ship since it did not increase the contrast quite as much. Although the image is moving in the right direction, the ship is still much too dark, so more adjustment is needed.

Since this adjustment needed to exclude the sky, the Magic Wand was used to select the sky, then the selection was inversed (Select>Inverse). The selection was then feathered by two pixels (Select>Feather). The selected area was copied and pasted to a new layer. To lighten the image,

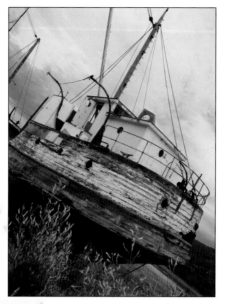

LEFT: *Image with the ship copied to a new layer and the new layer mode set to Screen.* ABOVE: *The Layers palette with the new layer mode set to Screen and the layer opacity set to 90%.*

the mode of this new layer was set to Screen. To reduce the effect slightly, the opacity of the layer was set to 90%.

To refine the exposure of the ship a bit more, with the ship layer still active the Curves were accessed and the composite curve was pulled up slightly in the center to lighten the midtones.

Second Image Evaluation. With this change made, the overall exposure balance was looking a lot better. However, the image could still use a little brightening, and it could probably be very slightly warmer. Since the exposure on the ship and foreground was now pretty well balanced, these changes could be made on a global scale—although it was still important to keep an eye on those light areas in the sky to make sure they did not become too light or lose detail.

Global Corrections with Auto Color and Curves. Sometimes the Auto Color function happens to work very well—as it did in this case, enhancing the overall contrast and removing most of the cool color cast.

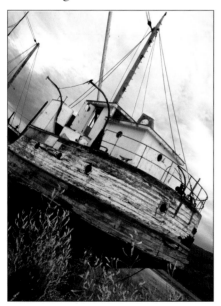
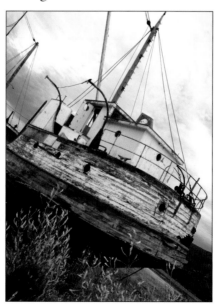

LEFT: *Image after application of Auto Colors tool.* RIGHT: *Image with the blue channel reduced in the midtones via the Curves tool.*

If you wanted a cooler look, this could be the end point in your corrections to the image. To create a warmer look (as seen in the bottom right photo below), the Curves tool was opened and the blue channel pulled down very slightly.

The final aspect of this image that was noted for correction was the red paint on the bottom part of the hull of the ship. After using the Eyedropper tool to select a foreground color from one of the small areas of dark red that were still visible on the wood, the Brush tool was selected. Then, a new layer was created and set to the color mode, allowing the red color to be painted onto the wood without obscuring its texture. Setting the opacity of the brush to about 50% and working with streaky strokes helped ensure that the effect looked natural, as did reducing the opacity of the layer to about 60% before flattening the image.

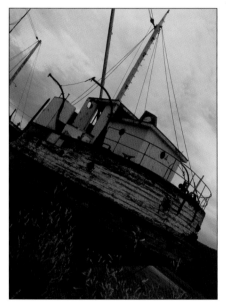

ABOVE: *The original image.* RIGHT: *The corrected image.*

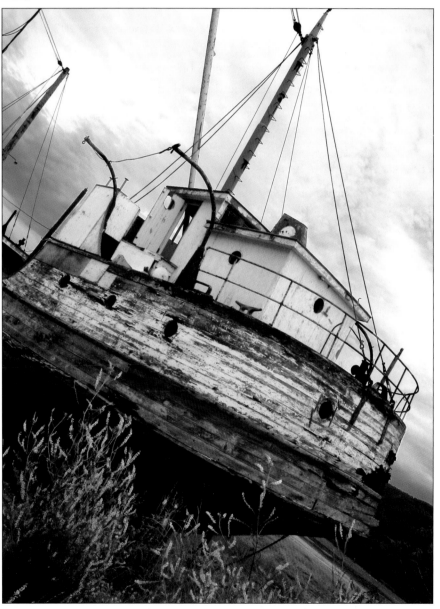

11. Color Enhancements

In quite a lot of cases, the look you are seeking in your image may have very little to do with how the scene or subject actually looked. The creative changes you can make to color are only as limited as your imagination, but the following sections provide instructions for creating some commonly used color effects.

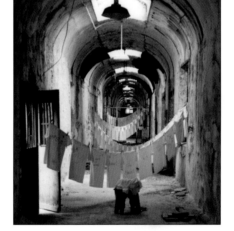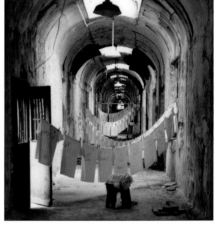

LEFT: *The original image for the Hue/Saturation method.* RIGHT: *The image with a sepia tone added.*

● TONING

Toning an image adds overall color. This effect is normally used with black & white images, but your imagination is the only limit. The most commonly added tone is probably sepia (a brownish tone), but don't stop there—you can add any tone you like with Photoshop. Try out as many colors as you feel like before deciding on the best one, keeping in mind that you can adjust the intensity of the effect precisely to your liking. Some interesting looks are demonstrated on the following pages.

Hue/Saturation Method
1. Begin with a digital image in the RGB mode.
2. Open the Hue/Saturation dialog box (Image>Adjustments> Hue/Saturation). Click on the Colorize box and be sure to activate the Preview box, as well.
3. Adjust the sliders to create whatever color (hue) and intensity of color (saturation) you like. Adjusting the lightness slider will adjust

Setting the Hue/Saturation dialog box to create a sepia tone.

the overall lightness of the image, which you can also do as you see fit. For the example shown on the facing page (top right), the hue was set to 23 and the saturation to 18. This creates a sepia effect. Adding a blue cast creates another nice look. To do this, follow steps 1–3 as above (remembering to click on the Colorize box), but set the sliders to hue=223, saturation=10, and lightness=0.

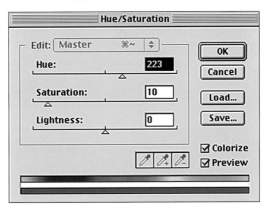
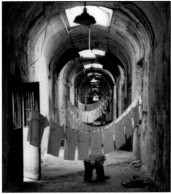

LEFT: *Setting the Hue/Saturation dialog box to create a blue tone.* RIGHT: *The image with a blue tone.*

Calculations/Channel Method

The following technique creates a more refined sepia (or other) toning effect.

THE FOLLOWING TECHNIQUE CREATES A MORE REFINED TONING EFFECT.

1. Begin with a black & white image in the RGB mode.
2. Create a new layer (Layer>New>Layer) and set its mode to Color.
3. Click on the foreground color swatch to activate the Color Picker and select the color you want to use as the "tone."
4. Fill the new layer with the selected color (the foreground color).
5. Go to Image>Calculations and use the settings shown below (right). For Source 1, set the Layer to Merged and the Channel to Gray. For Source 2, set the Layer to Layer 1 and the Channel to Gray. Set the Blending to Normal and the Opacity to 100%. For Result, select New Channel.

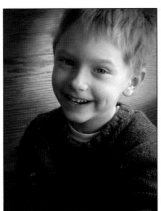

LEFT: *The original image for the calculations/channel method.* RIGHT: *The settings to make in the Calculations dialog box.*

6. Go to Select>Load Selection. The highlight areas of the image will be selected.

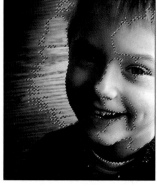

LEFT: *The Load Selection dialog box.*
RIGHT: *The resulting selection of the highlight areas of the image.*

7. Go to Image>Adjustments>Levels. In the dialog box that appears (below left) move the black slider to the right until it is under the left edge of the data in the histogram (below right). Move the highlight slider slightly to the left.

The Levels dialog box before adjustment (left) and after (right).

8. In the Channels palette, click on the composite RGB channel. Then (with the selection still active) go to Image>Adjustments> Desaturate.

9. Flatten the image (Layer>Flatten Image).

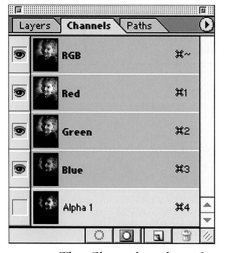

ABOVE: *The Channels palette for this image with the new channel visible.* RIGHT: *The final image.*

TOP LEFT: *The original color image.* TOP RIGHT: *For comparison, the color image converted directly to Grayscale.* BOTTOM LEFT: *The color image converted to digital infrared (note the white foliage and characteristic glow).* BOTTOM RIGHT: *The same digital infrared image with the addition of infrared's characteristic black sky.*

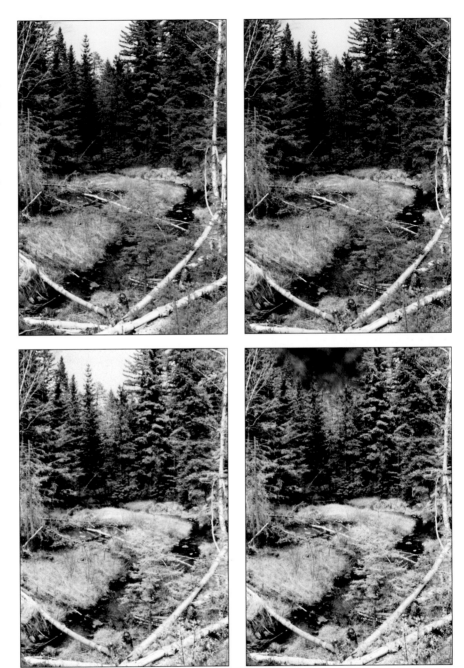

5. Deactivate the selection in the channel by clicking on it with the Marquee tool.

6. Apply a Gaussian blur to the channel (Filter>Blur>Gaussian Blur). Two to five pixels will be sufficient.

7. Return to the background image in the Layers palette.

8. Load the new selection (Selection>Load Selection).

9. Since there is no detail to preserve, fill the area with whatever shade of gray you like using the Fill command (Edit>Fill), Brush tool, or any other means you wish.

10. To add clouds, use the cloud filter (Filter>Render>Clouds).

11. Adjust the brightness and contrast of the clouds (Image>Adjustments>Brightness/Contrast) until satisfied.

12. Add the same amount of grain (Filter>Noise>Add Noise) as you did to the rest of the image. (Note: Even if you added none, care fully add enough at this point to make the newly created sky match up with the grain in the rest of the photograph).

Variations

Depending on the tones and colors in the image you select, you may need to adjust the settings in the Channel Mixer (step four) to optimize the effect. If you want to maintain the original brightness of the image, make sure that the percentage values for the three sliders total +100.

For images without many green tones (below left), you may find it helpful to tweak the Curves before applying the Channel Mixer. A straight conversion with the Channel Mixer made the skin tones too dark in this case. To compensate, the image was lightened by pulling down on the center of the composite curve (Image>Adjustments> Curves), and the curve for the red channel was pulled down to give the image a green/blue cast (below center). After applying the Channel Mixer and playing with the settings a bit, the results were much better. The rest of the previously discussed procedure was then followed from step five without any need for alteration (below right).

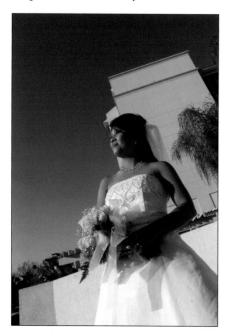 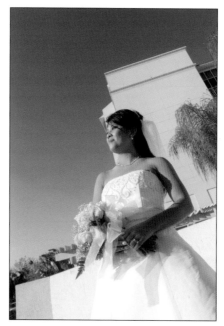 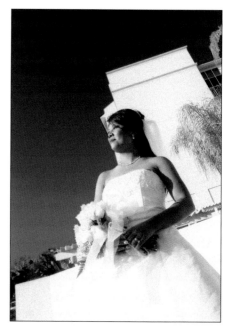

LEFT: *Original photograph by Jeff Hawkins.* CENTER: *Photograph adjusted to enhance the results of the conversion to digital infrared.* RIGHT: *The final image in its digital infrared incarnation.*

● HANDCOLORING

Handcoloring black & white photos (or color ones for that matter) is usually accomplished with a variety of artistic media—oil paints, pencils, etc. If you've ever actually colored an image by hand, you know how much time it takes—and also how small mistakes can have you desperately trying to remove colors with various solvents and bleaches.

With Photoshop, the process is remarkably easy—and if you goof or change your mind you can just hit Edit>Undo (or use the History palette to backtrack if you didn't notice the problem right away). For those of you who never got the hang of coloring, you can create selections or masks to help you stay inside the lines. You can also try out lots of different looks and experiment freely with colors before deciding what works best.

Like most tasks, handcoloring in Photoshop can be accomplished in several ways: the use of layers in the color mode, the use of the Hue/Saturation command, or by using the Eraser tool on desaturated layers. We'll begin working simply with color layers, since this is the most intuitive method.

Handcoloring with Color Layers

1. Begin with an image in the RGB color mode (Image>Mode>RGB). The image must be in a color mode or you will not be able to add color to it. If you want to add handcolored effects to the color image, proceed to step two. For the more traditional look of handcoloring on black & white, go to Image>Adjustments>Desaturate to create a black & white image in the RGB color mode.

LEFT: *Original photograph by Rick Ferro.* RIGHT: *Photograph converted to Grayscale.*

2. Create a new layer (Layer>New>Layer) and set it to the color mode.

Setting the new layer to the color mode.

3. Double click on the foreground color swatch to activate the Color Picker. Select the color you want and hit OK to select it as the new foreground color. This is the color your painting tools will apply. You may switch it as often as you like.

4. With your color selected, return to the new layer you created in your image. Click on this layer in the Layers palette to activate it, and make sure that it is set to the Color mode.

5. Select the Brush tool and whatever size/hardness brush you like, and begin painting. Because you have set the layer mode to color, the color you apply with the brush will allow the detail of the underlying photo to show through.

6. If you're a little sloppy, use the Eraser tool (set to 100% in the options menu) to remove the color from anywhere you didn't mean to put it. Using the Zoom tool to move in tight on these areas will help you work as precisely as possible.

7. If you want to add more than one color, you may wish to use more than one layer, all set to the Color mode.

8. When you've completed your "handcoloring," the image may be either completely or partially colored. With everything done, you can flatten the image and save it as you like.

TOP: *Selecting a color from the Color Picker.* RIGHT: *Activating the layer you want to paint on.*

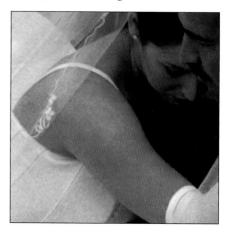

If you make any mistakes (like the pink on the bride's glove and the strap of her dress), you can touch them up using the Eraser tool.

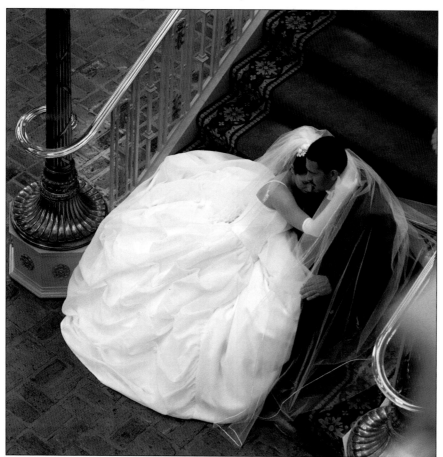

The final image can feature handpainted tones that are realistic or fantastic, subtle or intense—it's up to you!

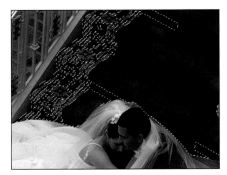

Selecting the area to which color is to be added.

TOP: *Creating a new Hue/ Saturation adjustment layer.* ABOVE: *Adjusting the Hue/Saturation settings.*

Handcoloring with the Hue/Saturation Mode

This method is, perhaps, a little trickier than the one previously described because it relies on your ability to make accurate selections using the Marquee and Magic Wand tools. It works best when applying solid colors to a large area of the image. In this case, it is demonstrated on the stairs.

1. Begin with a black & white image in the RGB color mode (Image>Mode>RGB). The image must be in a color mode or you will not be able to add color to it.
2. Carefully select the area of the photograph to which you will add color.
3. Feather the selection (Select>Feather). For most purposes, feathering by two pixels will create a natural-looking transition between the selected and unselected areas. For softer transitions (say, to add a soft pink on someone's cheeks), you may need to feather the selection considerably more.
4. With the selection made, create a new adjustment layer to adjust the Hue/Saturation (Layer>New Adjustment Layer>Hue/Saturation).
5. Clicking OK in the New Layer dialog box will open the Hue/Saturation dialog box.
6. Click the Colorize button at the lower right of the box.
7. Move the hue, saturation, and lightness sliders until you achieve the desired coloration. The hue slider moves from red, to greens, to blues as you go from left to right. The saturation slider decreases saturation when moved to the left and increases saturation when moved to the right. To darken, slide the lightness control to the left; to lighten, slide it to the right.
8. When you have adjusted the coloration to your satisfaction, click OK.

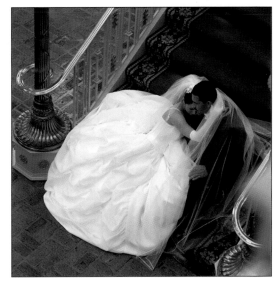

The digitally handcolored image now features purple stairs, a departure from the original image.

9. Since you have applied this operation on an adjustment layer, you can adjust the layer mode and opacity from within the Layers palette. Double clicking on the layer will re-open the Hue/Saturation dialog box if you decide you need to make a change. If you feel the texture seems reduced after applying this technique, go to Layer>Layer Style>Blending Options and move the black slider under This Layer a bit to the right.

Adjusting the layer blending.

Desaturating with Layers

Here's a quick way to add a handcolored look in seconds—or, with a little refinement, to avoid having to select colors to handcolor with. This technique works only if you are starting with a color image.

1. Begin with a color image in the RGB or CMYK mode.
2. Duplicate the background layer by dragging it onto the duplication icon at the bottom of the Layers palette.
3. Desaturate the background copy by going to Image>Adjustments>Desaturate. The image will turn black & white—but by reducing the opacity of the desaturated layer you can allow the col-

Duplicating the background layer.

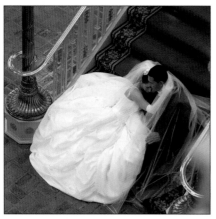
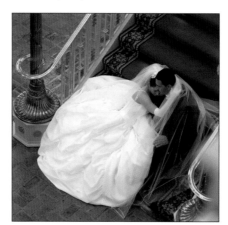
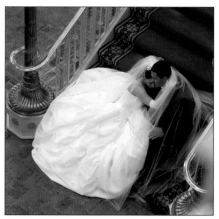

Reducing the opacity of the desaturated layer lets the underlying color show through. From left to right, the layer opacity was set to 80%, 60%, and 40%.

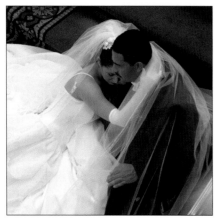
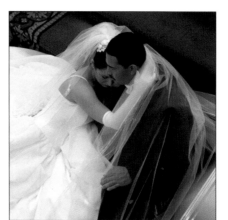
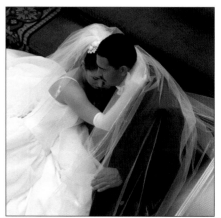

Erasing the desaturated layer also lets the underlying color show through. Here, the opacity of the Eraser tool was set to (from left to right) 20%, 40%, and 60%.

12. Converting Images to Black & White

When you print a color negative on black & white paper you'll usually notice an objectionable loss of contrast. This can be bumped up using a higher contrast paper (or contrast filters with multi-contrast paper). Much the same thing will happen if you convert a color image to Grayscale in Photoshop using the Image>Mode>Grayscale command. Using this command will cause Photoshop to mix all of the original color channels into the one monochrome channel.

Fortunately, even if the Grayscale color mode is the final destination of your image, there are some things that you can do to make the transition as graceful as possible.

● COLOR CORRECTION

With any conversion to black & white, you'll have the best results if the image is good to begin with—accurately color balanced, with good contrast and detail in the highlights and shadows. It may seem odd that color correction would come into play when creating black & white images, but it's an important step.

● IMAGE SELECTION

You'll be happiest when you select photos to "transform" that have a strong design and don't rely pri-

When color images with poor contrast and color balance (left) are converted to Grayscale, the result is a flat black & white image (right).

Taking the time to color correct the image (left) before converting to black & white will result in crisper tones and more pleasing contrast (right).

marily on color for their impact. Obviously, this is not always possible (say, if your color photo is to be used in a newspaper and color isn't an option). In this event, using the techniques described will be especially important for creating the best possible results.

● BLACK & WHITE IMAGES IN COLOR MODES

Don't overlook the possibility of presenting your black & white image in a color mode. For images to be used on the Internet (whether on a web page or as e-mail attachments), using the RGB mode will make your images look much better. In color printing, you can print a Grayscale image in your color brochure—but why? Using the four inks available in the CMYK process will always provide richer, more pleasing results.

● CONVERTING DIRECTLY TO GRAYSCALE

Once you have color corrected your image and have achieved a good tonal range and contrast, you are ready to convert the image to black & white. In this process, your final product will be an image in the Grayscale mode—just what you'll need for single-ink printing in a newspaper, newsletter, etc.

1. Go to Image>Mode>Grayscale to make the initial conversion. The results should be quite good, but you should still take the time to evaluate whether some small adjustments could improve the results.
2. Start evaluating the image by looking at the Levels. In the example below, the image and histogram look pretty good. The histogram extends just about from edge to edge in the window, indicating that the image contains a full range of tones (from white to black).

LEFT: *The image converted to Gray-scale.* RIGHT: *The histogram for the image.*

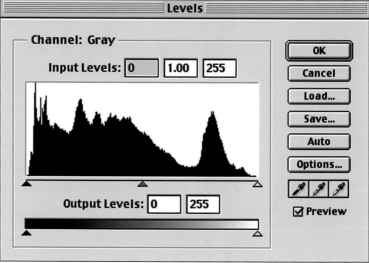

3. However, without the colors, the image still looks a little gloomy. Brightening the midtones will frequently help the appearance of a black & white image. You can do this while you have the Levels

dialog box open, by simply moving the center slider (the gray triangle) slightly to the left.

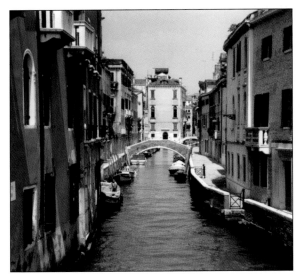
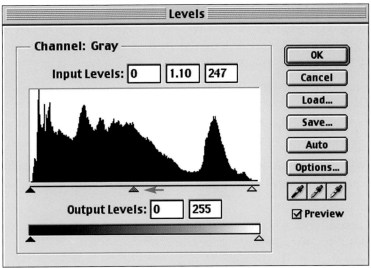

ABOVE (LEFT AND RIGHT): *The mid-tone slider is moved slightly to the left to brighten the midtones.*

4. Depending on your taste, you may still want to bump up the contrast a bit. You can do this in a few ways, with varying degrees of control. The easiest way is to go to Image>Adjustments>Brightness/Contrast. By dragging the contrast slider to the right, you can increase the contrast. However, the contrast function applies an identical change to every pixel in the image (if you set it to +10, that change will apply universally to the shadows, highlights, and midtones). This doesn't give you much control.

5. A better way to adjust contrast is to use the Curves, where you can be much more specific about where and how you build contrast. To begin, open the Curves dialog box by going to Image>Adjustments>Curves. You'll now notice that, instead of multiple channels, the image has only one channel—gray.

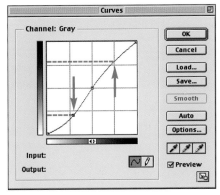

6. If you are happy with the midtones in the image (the middle grays don't look too dark or too light), you can nail these down by placing a point in the center of the curves line without moving it up or down. (As you make your changes to the contrast, you can always adjust this, but it's a good place to start.)

LEFT: *Putting an anchor in the center of the curves line nails down the midtone value.* RIGHT: *Pulling down on the lower part of the curve causes the upper part of the curve to move up. Remember, where you make the line steeper, you are increasing the contrast. Where it becomes more shallow, you are reducing the contrast.*

7. To increase the contrast in the image, click on the line about halfway between the midtone and white point and pull

down slightly. You'll see that the midpoint stays in place, while lighter tones move toward even lighter, and the darker tones move toward even darker (use the gradient bar at the left of the grid as your guide). This yields the increase in contrast. (If you want to reduce contrast for some reason, you can do just the opposite, pulling the darker tones toward lighter and the lighter tones toward darker.)

In the large image below you can see the results of applying the curve shown on the previous page. The contrast is much better. When applying curves to improve contrast, try to keep the curve itself as smooth as possible to achieve the most natural results. You can add as many points as you like, but usually two or three will be all that are needed. Also, keep an eye on the brightest highlights and darkest shadows to ensure that detail is not lost in these areas.

KEEP AN EYE ON THE BRIGHTEST HIGHLIGHTS AND DARKEST SHADOWS TO ENSURE THAT DETAIL IS NOT LOST.

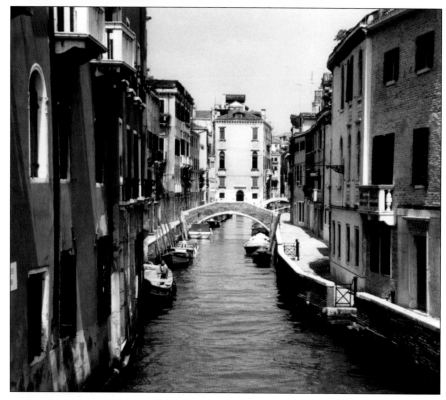

ABOVE: *The Grayscale image after slight adjustment using the Curves.* LEFT: *For comparison, the image converted to Grayscale without any refinements in the Curves.*

Original photograph by Jamie Rae Conley.

Converting a color image to black & white using this method produces a crisp image with very little grain and deep blacks.

1. Open an RGB image. If there are any layers in the image, flatten them.
2. Go to Image>Mode>Lab Color.
3. In the Channels palette (Window>Channels), click on the Lightness channel to change your image to black & white.
4. Drag the "a" channel into the trash can at the bottom of the palette (leaving this in place isn't a problem, but it will create an unneeded alpha channel).

LEFT: *Selecting the Lightness channel in the Channels palette.* RIGHT: *After throwing the "a" channel in the trash, your Channels palette should look like this.*

5. Go to Image>Mode>Grayscale, then Image>Mode>RGB. (You cannot convert directly to RGB from Lab Color.)
6. If you like, you can still review the histogram in the Levels dialog box to ensure the tones are represented in the best way possible.

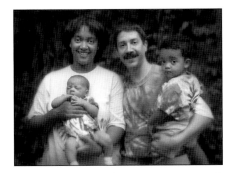

ABOVE: *Original image converted to the Grayscale mode.* RIGHT: *The same image converted to black & white using the Lab Color mode method—a much better result!*

As discussed in chapter 11, going to Image>Adjustments>Desaturate is a quick way to convert a color image to black & white. However, it results in slightly more grain than the Lab color method and produces slightly flatter results. It's still a useful operation, since you can apply the change to a layer (unlike with the Lab method). For more on this, see page 106. For comparison, examples using the various conversion techniques are shown below.

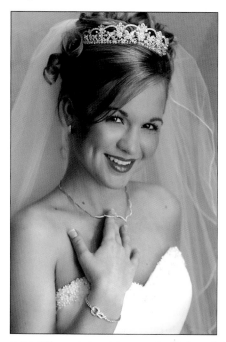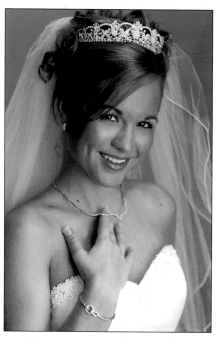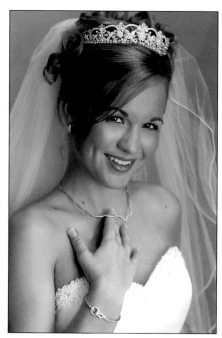

LEFT: *The original image by Deborah Lynn Ferro.* CENTER: *The image after being desaturated.* RIGHT: *Desaturating a duplicate background layer lets you create handcolored effects.*

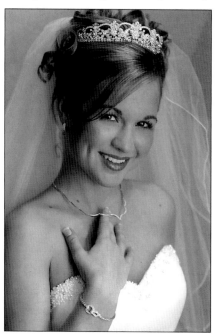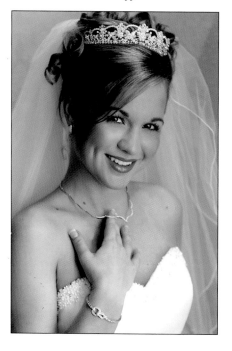

LEFT: *The image converted directly to the Grayscale mode.* RIGHT: *The image converted using the Lab Color mode method.*

tidges) can throw things off, so try to reduce the variables by keeping these as constant as possible. Begin by printing an image and evaluating it under daylight. If it looks good, save or note the settings you used and use them for future prints. If the print doesn't look good, identify the problem (say, a blue cast) and adjust the printer's settings using the on-screen printer software. Print again, evaluate, and continue tweaking the printer's settings until you are happy with the results—then note or save the settings you used. As the printer ages and you change cartridges, you may need to update these settings.

Most photo-quality ink-jet printer software allows you to adjust the color output using very intuitive sliders. Check your printer's manual for information on the custom settings available.

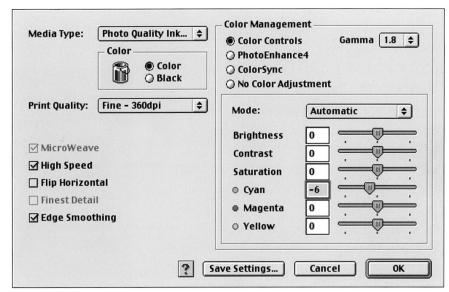

Lab Printing. Sending your digital files to an on-line lab (www. Snapfish.com is a popular consumer site) or taking them to your local photo lab is a convenient way to create true photographic prints. Many department stores and club stores now offer this service as well. In addition to their superior appearance and archival quality, the prices for lab-made prints are actually less than you'd pay to make the same prints at home.

As with home printing, you'll need to start with a test print. Prepare one image and have it printed by the lab you want to use (a 4"x6" should be about twenty to thirty cents, so this won't break the bank). When you get the print back, open the image file on your screen and compare the print to it. In most cases, you'll probably be pretty satisfied that the two match reasonably well (and your print may look even better than you expect).

If you are not happy with the results, the only part of the process you can control is the image file and the way it appears on screen. This would be the time, then, to recalibrate your monitor using any of the numerous products available for this process. Software products, which provide an on-screen visual system of calibration, work quite well and are inexpensive. Hardware products (featuring a colorimeter that actually attaches to the surface of your monitor and reads the color that it

produces) are quite a bit more expensive but provide the most accurate results. Based on these calibrated settings, an ICC color profile can be imbedded in your image file, helping to ensure that its color will reproduce correctly when you send it to the lab.

● OFFSET PRINTING

Images that are printed in books, magazines, and in other products created on a printing press must be converted to the CMYK mode. While the mechanics of this seem simple—just go to Image>Mode>CMYK, right?. Unfortunately, it isn't at all simple to get good results.

Here is the key problem: in addition to creating colors differently, different devices have a greater or lesser overall ability to produce colors at all. For example, our eyes see a wide range of colors, but film captures only a fraction of what the eye sees, monitors display only a fraction of those colors, and printers and presses produce even fewer.

Let us take as an example the difference between colors produced on a monitor and those produced on a printing press. A monitor produces color through its pixels, each of which contain three phosphors (one red, one blue, one green—thus RGB). By varying the brightness of these phosphors, all the colors from black (all phosphors off) to white (all phosphors on) are produced. A printing press produces colors by applying layers of semitransparent inks over each other. The fours inks normally used are cyan, magenta, yellow, and black—thus CMYK ("K" being the printer's abbreviation for black). By varying the concentration of the inks, colors are produced.

When an image moves from a monitor (RGB) to a printer (CMYK), the colors must be converted—and this in and of itself is no problem. The real problem is that the printer simply can't produce as many colors as the monitor. For example, the white in a printed image cannot be the same as the white you see on your monitor—it can only be as white as the paper on which the image is printed. The black achieved when printing will also never be the same as the black on your monitor. Bright blues and reds are also notoriously problematic in this transformation, but bright colors in general can pose problems. Because these colors can't be reproduced, they have to be changed into other colors that can.

Images with saturated color can be difficult to render in CMYK. With careful attention, however, you can achieve good results.

While some images will make the transition from RGB to CMYK with very little or no visible change, others will suddenly look awful—and subtle tones that once created delicate detail may disappear leaving flat, ugly areas in your image.

When you encounter such an image, you'll have another set of preflight questions to ask yourself: What areas of detail are important? Would I be willing to reduce the contrast or saturation in this area to keep the detail? Would I be willing to sacrifice a little bit of local color fidelity to achieve a better overall image? Once you've answered these questions, you can use the same tools and strategies seen throughout this book to begin addressing your concerns and making the needed adjustments.

Don't be frustrated if you have trouble getting just the results you want—preparing images for press is a specialty that people spend years learning to do well. That said, until you get the hang of it and feel confident that you can consistently anticipate the final results, it pays to work closely with your professional printer. Ask for the expert advice of their staff and discuss low-cost color proofing options that will help you identify problems *before* you've paid for a whole press run of postcards, brochures, etc.

If you are submitting your images to a publisher, be sure to ask if they even want you to do the RGB to CMYK conversion yourself. They may prefer to delegate this task to their own designers or professional digital imagers, who are experienced with the unique qualities of the publication's paper stock and the preferences of their printer.

DON'T BE FRUSTRATED IF YOU HAVE TROUBLE GETTING JUST THE RESULTS YOU WANT.

Additional Resources

● GETTING STARTED

Perkins, Michelle. *Beginner's Guide to Adobe® Photoshop®*. Amherst Media, 2004.

● PRE-PRESS IMAGING

Margulis, Dan. *Professional Photoshop*. John Wiley & Sons, 2002.

Rogondino, Michael and Pat. *Process Color Manual: 24,000 CMYK Combinations for Design, Pre-Press and Printing*. Chronicle Books LLC, 2000.

Williams, Robin and Sandy Cohen. *The Non-Designer's Scan and Print Book*. Peachpit Press, 1999.

● DIGITAL PHOTO RETOUCHING

Audleman, Al. *Photographer's Guide to the Digital Portrait: Start to Finish with Adobe® Photoshop®*. Amherst Media, 2004.

Drafahl, Jack and Sue. *Photo Salvage with Adobe® Photoshop®*. Amherst Media, 2003.

Ferro, Rick and Deborah. *Wedding Photography with Adobe® Photoshop®*. Amherst Media, 2003.

Hamilton, Maurice. *The Digital Darkroom Guide with Adobe® Photoshop®*. Amherst Media, 2004.

Lute, Gwen. *Photo Retouching with Adobe® Photoshop®*. Amherst Media, 2003.

Montizambert, Dave. *Professional Digital Photography: Techniques for Lighting, Shooting, and Image Editing*. Amherst Media, 2003.

Perkins, Michelle and Paul Grant. *Traditional Photographic Effects with Adobe® Photoshop®*. Amherst Media, 2004.

● PROFESSIONAL DIGITAL PHOTOGRAPHY

Coates, Bob. *Professional Strategies and Techniques for Digital Photographers*. Amherst Media, 2004.

Hawkins, Jeff and Kathleen. *Digital Photography for Children's and Family Portraiture*. Amherst Media, 2004.

Hawkins, Jeff and Kathleen. *Professional Techniques for Digital Wedding Photography, 2nd Edition*. Amherst Media, 2003.

Smith, Jeff. *Professional Digital Portrait Photography*. Amherst Media, 2003.

● WEB-SITE IMAGING

Berryhill, Gene. *Designing Web Site Images: A Practical Guide*. Delmar Learning, 1999.

Rose, Paul and Jean Holland-Rose. *Web Site Design for Professional Photographers*. Amherst Media, 2003.

Index

Also by Michelle Perkins . . .

Beginner's Guide to Adobe® Photoshop®

Learn to effectively make your images look their best, create original artwork, or add unique effects to any image. Topics are presented in short, easy-to-digest sections that will boost confidence and ensure outstanding images. $29.95 list, 8½x11, 128p, 300 color images, order no. 1732.

By Michelle Perkins and Paul Grant . . .

Traditional Photographic Effects with Adobe® Photoshop®

Use Photoshop to enhance your photos with vignettes, soft focus, and much more. Every technique contains step-by-step instructions for easy learning. $29.95 list, 8½x11, 128p, 150 color images, order no. 1721.

Outdoor and Location Portrait Photography
2nd Ed.
Jeff Smith

Learn to work with natural light, select locations, and make clients look their best. Packed with step-by-step discussions and illustrations to help you shoot like a pro! $29.95 list, 8½x11, 128p, 80 color photos, index, order no. 1632.

Wedding Photography
CREATIVE TECHNIQUES FOR LIGHTING AND POSING, *2nd Ed.*
Rick Ferro

Creative techniques for lighting and posing wedding portraits that will set your work apart from the competition. Covers every phase of wedding photography. $29.95 list, 8½x11, 128p, 80 color photos, index, order no. 1649.

Corrective Lighting and Posing Techniques for Portrait Photographers
Jeff Smith

Make every client look their best by using lighting and posing to conceal real or imagined flaws—from baldness, to acne, to figure flaws. $29.95 list, 8½x11, 120p, 150 color photos, order no. 1711.

Professional Marketing & Selling Techniques for Wedding Photographers
Jeff Hawkins and Kathleen Hawkins

Learn the business of wedding photography. Includes consultations, direct mail, advertising, internet marketing, and much more. $29.95 list, 8½x11, 128p, 80 color photos, order no. 1712.

Professional Techniques for Digital Wedding Photography, *2nd Ed.*
Jeff Hawkins and Kathleen Hawkins

From selecting equipment, to marketing, to building a digital workflow, this book teaches how to make digital work for you. $29.95 list, 8½x11, 128p, 85 color images, order no. 1735.

Success in Portrait Photography
Jeff Smith

Camera skills alone do not ensure success. This book will teach photographers how to run savvy marketing campaigns, attract clients, and provide top-notch customer service. $29.95 list, 8½x11, 128p, 100 color photos, order no. 1748.

Professional Digital Portrait Photography
Jeff Smith

Making the transition to digital can be frustrating. Author Jeff Smith shows readers how to shoot, edit, and retouch their images—while avoiding common pitfalls. $29.95 list, 8½x11, 128p, 100 color photos, order no. 1750.

The Bride's Guide to Wedding Photography
Kathleen Hawkins

Perfect for brides or photographers who want their clients to look their best. $14.95 list, 9x6, 112p, 115 color photos, index, order no. 1755.

Wedding Photography with Adobe® Photoshop®

Rick Ferro and Deborah Lynn Ferro

Get the skills you need to make your images look their best, add artistic effects, and boost your wedding photography sales with savvy marketing ideas. $29.95 list, 8½x11, 128p, 100 color images, index, order no. 1753.

Digital Photography for Children's and Family Portraiture

Kathleen Hawkins

Learn how digital photography can boost your sales, enhance your creativity, and improve your studio's workflow. $29.95 list, 8½x11, 128p, 130 color images, index, order no. 1770.

The Portrait Book

A GUIDE FOR PHOTOGRAPHERS

Steven H. Begleiter

A comprehensive textbook for those getting started in professional portrait photography. Covers every aspect from designing an image to executing the shoot. $29.95 list, 8½x11, 128p, 130 color images, index, order no. 1767.

The Digital Darkroom Guide with Adobe® Photoshop®

Maurice Hamilton

Bring the skills and control of the professional photographic darkroom to your desktop with this comprehensive manual—a must for digital imaging. $29.95 list, 8½x11, 128p, 140 color images, index, order no. 1775.

Professional Strategies and Techniques for Digital Photographers

Bob Coates

Learn how professional photographers—from portrait artists to commercial specialists—enhance their images with digital techniques. $29.95 list, 8½x11, 128p, 130 color photos, index, order no. 1772.

PHOTOGRAPHER'S GUIDE TO

The Digital Portrait

START TO FINISH WITH ADOBE® PHOTOSHOP®

Al Audleman

Follow through step-by-step procedures to learn the process of digitally retouching a professional portrait. $29.95 list, 8½x11, 128p, 120 color images, index, order no. 1771.

Professional Digital Photography

Dave Montizambert

From monitor calibration, to color balancing, to creating advanced artistic effects, this book provides those skilled in basic digital imaging with the techniques they need to take their photography to the next level. $29.95 list, 8½x11, 128p, 120 color photos, order no. 1739.

Photo Retouching with Adobe® Photoshop® 2nd Ed.

Gwen Lute

Teaches every phase of the process, from scanning to final output. Learn to restore damaged photos, correct imperfections, create realistic composite images, and correct for dazzling color. $29.95 list, 8½x11, 120p, 100 color images, order no. 1660.

The Best of Portrait Photography

Bill Hurter

View outstanding images from top professionals and learn how they create their masterful images. Includes techniques for classic and contemporary portraits. $29.95 list, 8½x11, 128p, 200 color photos, index, order no. 1760.